DYING

CRAFTS

DYING CRAFTS

Compiled by Gao Mo

FAN PHOTOGRAPHY

Dying Crafts

Compiled by Gao Mo

First English Edition 2023
ISBN: 978-1-4878-1104-4

Unit 604, 85 Beach Road, Central City, Auckland 1010, New Zealand

Contents

1.

Woodblock Printing for Copying Classics

Passed down from the Tang Dynasty (618-907), the woodblock printing process mainly comprises delineation by color, block cutting and printing, which ensures the works stay true to the original ones. The woodblock printing works produced by Rongbaozhai ("Studio of Glorious Treasures") of China Publishing Group Corporation (CPG) are world-renowned. Through continuous innovation and development, Rongbaozhai can skillfully print some large-scale artistic works such

Beijing Jianpu, commissioned by Lu Xun and Zheng Zhenduo, to be printed by Rong Baozhai.

as the painting of the *Galloping Horse*, the painting of the *Ladies with Flowers in Their Hair* created by influential Tang Dynasty painter Zhou Fang (unknown his exact dates of birth and death), and the work *Singing and Dancing in Fields* painted by Ma Yuan (unknown his exact dates of birth and death), an outstanding artist of the following Song Dynasty. So, let us enter the beautiful world of this particular craft with a history of nearly a thousand years.

Rongbaozhai's woodblock printing is derived from ancient block-based overprinting. This term refers to the overprinting of the original works by block after delineation and block cutting according to handwritten strokes and assigned colors, ensuring the printed works would be almost identical with the original ones. In May 2006, woodblock printing was officially included in the first China intangible cultural heritage list approved by the State Council.

Xiao Gang, an intangible cultural heritage successor of China, started working in the Rongbaozhai Editorial Office in 1978, where he mainly engaged in the graphic design of art books, and the design and delineation of woodblock printing works. He participated in the layout design and text editing of *Rongbaozhai Series of Picture Copybooks*, as well as the design and production of wall calendars. He participated in the design and coloring of main woodblock printing works based on such classic paintings as Xu Beihong's *Galloping Horses on Plains*, Qi Baishi's *Autumn Landscape* (long scroll, vertical axis, meticulous grass-and-insect painting), Zhou Fang's *Ladies with Flowers in Their Hair*, Zhang Zeduan's *Riverside Scene at Qingming Festival*, and copied works like Huang Binhong's *Landscape*, and Shu Tong's *Ba Chi Zi*, etc.

Origin of woodblock printing

Based on archaeological findings, woodblock printing in China emerged in the Tang Dynasty and was used to print Buddhist scriptures and images for a long time. In the Song Dynasty, especially during the reign of Emperor Huizong (1100-1125), woodblock printing enjoyed unprecedented popularity, when, apart from the aforementioned Buddhist scriptures and images, it was also adopted in the production of secular books and illustrations. It was further spread during the Liao Dynasty (907-1125) in northern China and the Western Xia Dynasty

Shizhuzhai Jianpu, commissioned by Lu Xun and Zheng Zhenduo to be printed by Rong Baozhai.

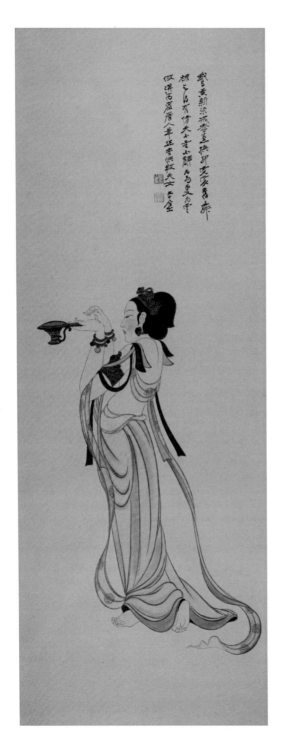

A piece of woodblock printing: Zhang Daqian's *Dunhuang Donors.*

(1038-1227) in Western China including Tibet.

In the Mongol-based Yuan Dynasty, lasting for less than a century from 1271-1368, woodblock printing continued to boom, and almost all religious books and technical works of various kinds had illustrations produced by this means. However, at the end of that dynasty, the printing and publishing business was suspended due to chaos caused by war, only to be revived during the reign of Ming Dynasty Emperor Shenzong (1572-1620), reaching new heights.

In the late Ming Dynasty, the printing industry was very developed despite the presence of much political corruption. A large number of books were published, and some distinctive genres of printing gradually came into being, including color printing that met needs of people from the upper class, and "non-standard" printing catering to the needs of ordinary people. Jianyang Bookstore in Fujian province published the largest number of "non-standard" books.

At that time, "Gonghua" (embossing technique) and color overprinting, also known as "watercolor block printing" was fully developed because there were a number of idle and rich officials with the high artistic accomplishments, and also many very wealthy merchants aspiring to join the prestigious art or literary circles of the day.

"Gonghua" and color overprinting were successively recorded in *Luoxuan Biangu Jianpu* (1626), *Shizhuzhai Huapu* (1627) and *Shizhuzhai Jianpu* (1644).

In nearly a century from the middle and late periods of the Qing

Dynasty, which lasted from 1644 to 1912, to the following period of the Republic of China, "Gonghua" and color overprinting, exquisite and elegant but very expensive, were basically discarded due to the chaos during the struggles for power of various warlords, while the single-block printing used to print New Year paintings still retained strong vitality.

History of Rongbaozhai woodblock printing

Rongbaozhai woodblock printing was inherited and developed based on the traditional watercolor block printing and woodblock printing techniques. Before its emergence, Chinese paintings could only be copied through manual imitation, heavily dependent on the copier's skills, and also an understanding of the original creator's intention and conception.

Perfect copying of a famous painting is even more time-consuming and difficult than the creation of a new painting. Due to the uniqueness of painting, and the limitations of copy technology, only a tiny minority of people could personally enjoy famous ancient paintings.

Before the emergence of promotional outlets such as touring exhibitions and high-simulation digital techniques, people had very limited opportunities to enjoy ancient paintings, and even contemporary art masterpieces, imposing obvious limits on the development of art appreciation and the emergence of new artists able to develop the necessary advanced skills.

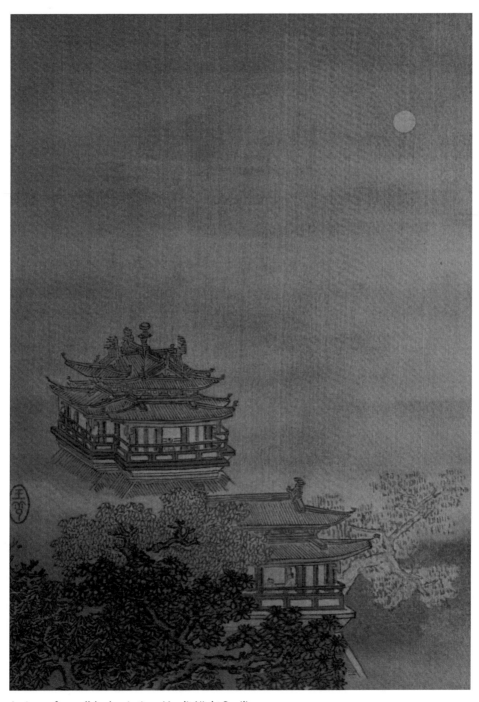

A piece of woodblock printing: *Moolit Night Pavilion.*

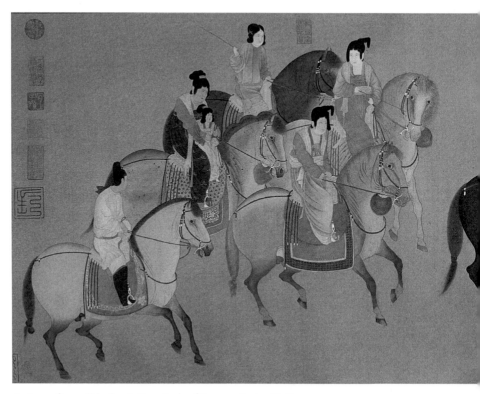

A piece of woodblock printing: *Lady of Guoguo Spring Outing.*

A painter's creation ability is very limited. Famous painters' works are usually in short supply. In order to meet a growing market demand, famous painters in the past often asked their disciples to produce works that imitated their own style, carefully choosing the best to append their signature, seals and inscriptions in order to promote a sale or be given as a present. During the period of the Republic of China, famous painters Zhang Daqian (1899-1983) and Pu Xinshe (1896-1963) followed this path.

Generations of excellent technicians and successors are the core of woodblock printing. Xiao Gang is one of the four national intangible

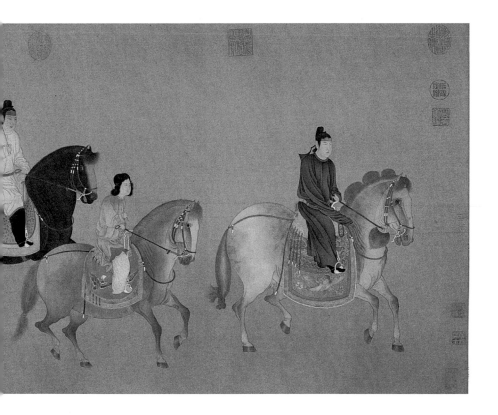

cultural heritage successors.

He began to learn woodblock printing in the 1970s, and studied under traditional Chinese painting masters such as Chen Linzhai and Guo Muxi. Since then, he has successively participated in production of large-scale woodblock printing works based on the original paintings *Lady of Guoguo Spring Outing* and *Ladies with Flowers in Their Hair.* After learning, all of the trainee group left, except for Xiao Gang, who continued to engage in delineation and editing work in Rongbaozhai due to his strong love of the craft.

Chinese Painting Masters Contribute to the Emergence and Promotion of Rongbaozhai Woodblock Printing

In 1896, Rongbaozhai set up the "Tietaozuo" agency, officially launching its woodblock printing business. In the beginning, it only produced some simple works such as paper for writing letters or poems. Rongbaozhai's early development in woodblock printing was occasionally and inevitably related to two Chinese painting masters Zhang Daqian and Xu Beihong (1895-1953, famous for his birds and horses' works), who made Rongbaozhai woodblock printing more elegant.

The birth of its woodblock printing can be traced to the end of 1945, when Mr. Zhang Daqian's *Dunhuang Donors* painting was copied. At that time, Rongbaozhai, by reprinting *Shizhuzhai Jianpu*, not only resumed the watercolor block printing business, but also improved some of the techniques, and mastered the key technology of copying according to the original size.

In 2006, Rongbaozhai's woodblock printing was officially included in the first China intangible cultural heritage list.

Due to these technical breakthroughs, the eminent artist Wang Renshan proposed to copy Zhang Daqian's *Dunhuang Donors*"painting according to its original size. The successful copying was an historic breakthrough in woodblock printing, and

Woodblock printing craft workshop.

also the birth of Rongbaozhai involvement in its promotion.

In the 1950s, Xu Beihong's *Galloping Horses on Plains* painting was printed, opening up a new situation of woodblock printing. Later, Mr. Qi Baishi repeatedly asked Rongbaozhai to copy his works because there was virtually no difference between original and copy. Indeed, Qi Baishi could not even identify the original *Shrimp* painting until the staff of Rongbaozhai pointed it out.

Xiao Gang thinks that painters usually accept woodblock printing works because they can play a positive promotional role. In fact, woodblock printing is a process of re-creation, not simply copying. In fact, many cultural and aesthetic elements are involved. "It is

completely handmade, and the production process is complicated. That was why Qi Baishi failed to distinguish between the original and the duplicate."

He continues: "Each of our woodblock printing works is marked, and enthusiasts have become familiar with the basic varieties. Thus, it will not disrupt the transactional market for original works, but will actually enhance the value of classic works and their artists.

Process of Rongbaozhai woodblock printing

The process of Rongbaozhai woodblock printing comprises delineation, block cutting and printing.

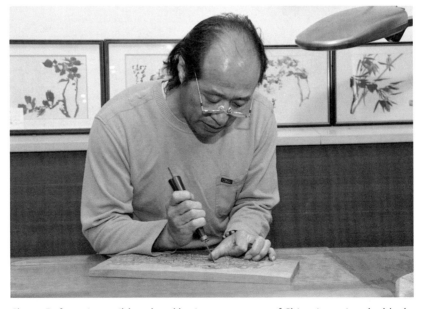

Chong Defu, an intangible cultural heritage successor of China, is cutting the block.

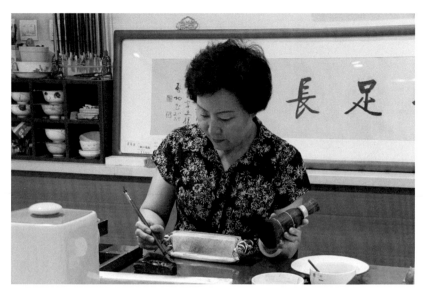

Gao Wenying, an intangible cultural heritage successor of China, is printing a piece of woodblock printing.

The first step is delineation, as follows: Cover the original work with celluloid paper, wipe it and cover it evenly with talcum powder; perform color separation according to printing needs, and delineate on the celluloid paper; use ganpishi (traditional paper made from various plant fibers) to cover the sample manuscript on the celluloid paper after color separation, and then re-delineate; finally, compare the finished product with the original, and refine it.

Xiao Gang goes on to explain: "The brush, ink, and paper all form a coherent whole in the delineation. For freehand brushwork, I will delineate using the brush first, then perform color separation on the original work covered by celluloid paper, and pave ganpishi on the celluloid paper to re-copy. Delineation on ganpishi must be accurate in form and content, which is the premise for printing and making a work that accurately duplicates the original."

Use of dry brush is difficult for delineation. Generally, the brush side part must be composed of continuous points and lines. Dry ink must be used because wet ink will permeate the paper. This is the basic brushwork requirement.

The second step is block cutting, as follows: Use a red and blue pencil to determine the position of the ganpishi sample manuscript on the board, evenly apply paste, and reverse paste the rough sketch on the board; rub and remove the surface fiber of ganpishi, and put the sketch and the board in a shade place to dry; use a knife to outline from shallow to deep cuts along the lines, and finally remove the excess part according to the actual situation.

The third step is printing, as follows: Fix the engraved woodblock on the table according to the original painting position, and color according to the original artistic style, shade and dryness; brush the pigment on the woodblock according to original work, and use a rake to move the pigment on the woodblock to Chinese art paper; finally, manually polish the watermark work with water on the desired position.

Road of woodblock printing inheritance

In the past, Rongbaozhai mainly copied works of painting and calligraphy, targeting only painting and calligraphy professionals, collectors and art lovers. General consumers were considered not to understand the difference between common high-imitation calligraphy and painting works and woodblock printing works. In

Wang Li, an intangible cultural heritage successor of China, is printing a piece of woodblock printing.

fact, the difference between them is very large. High-imitation works of calligraphy and painting are made through machine printing after high-precision scanning, and they, like photos, are different from the original. In contrast, the paper and pigment used for woodblock printing are exactly the same as the original, and pieces of wood replace the writing brush.

Woodblock printing aims to create "a works just the same as the original". Each woodblock printing work is an artistic creation reflecting the wisdom and effort of the creator. This is also the core value of woodblock printing. Nowadays, Rongbaozhai is making further experimentation in development of cultural and creative products and tourist souvenirs. The artwork close to life will make the traditional woodblock printing process advance in line with the times.

Xiao Gang, an intangible cultural heritage successor of China, is delineating the manuscript.

Xiao Gang thinks Rongbaozhai will achieve further good development, and continue to carry forward the fine craft on the basis of inheritance. First of all, the traditional handicraft should be inherited and carried forward to protect its status as an intangible cultural heritage. Innovation and inheritance are needed for traditional culture. Without innovation, there will be no vitality. Innovation is a new understanding or a new discovery within the traditional scope. Innovation, however, must always ensure an inheritance that is authentic and complete.

At present, Xiao Gang has three apprentices, who are all college students of fine arts. As his teacher did before, he teaches them theoretical knowledge, enables them to participate in some art exhibitions, expounds painting styles, and imparts to them calligraphy skills from scratch.

Xiao Gang also teaches them imitation skills, saying: "They are all professionals in painting. What I need to do is to help them grasp woodblock printing skills. I ask them to copy some works instead of only creating. Gradually, they master the skills of woodblock printing."

2.

Super Enamel Craftsmanship of the Xiong Family Stands out in Modern Times

An enamel product has to undergo 53 steps last at least two months to completion. Enamel making has a history of 600 years. In earlier times, such products were considered luxuries much favored by the royal family and nobility. The exquisite enamel craftsmanship of Xiong Songtao has helped him win many orders from several famous Swiss watch companies seeking customized enamel dials. Xiong Songtao is a legendary figure in the enamel processing industry of China. Carrying forward his family's enamel craftsmanship and fine traditions, he enthusiastically takes on a self-imposed challenge

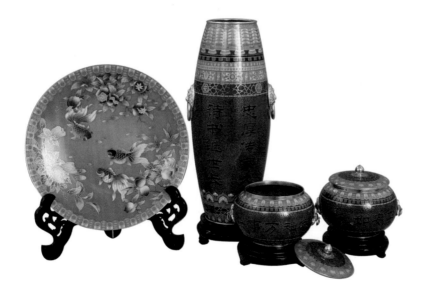

A piece of enamel craftsmanship: Zhong Liansheng's *Beijing Style series.*

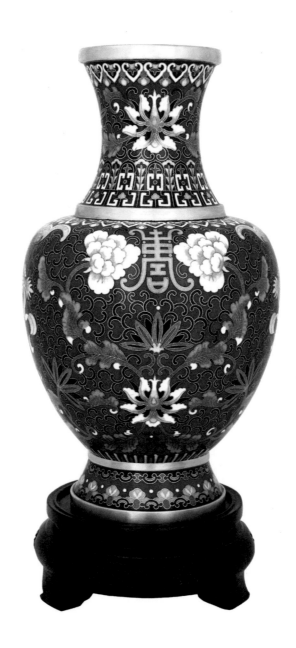

A piece of enamel craftsmanship: Qian Meihua's
Fu Shou Zhouqilei Cloisonne Vase.

enabling him to even surpass European enamel processing masters.

Enamel work, also known as "cloisonné" spread from Persia to China during the Yuan Dynasty. Mass production began in the following Ming Dynasty, reaching a peak during the reign of Emperor Jingtai (1450-1457). Cloisonné vessels that have been preserved were hand-made largely from the Qing Dynasty, reflecting very complex craftsmanship. The vessels collected are much cheaper than the porcelain made in official kilns over the same period, thus having relatively larger appreciation potential. The adopted name of cloisonné means "wiry enamel".

Xiong Songtao is the present inheritor of enamel craftsmanship of his family. His grandfather studied in the Royal Workshop (Zaobanchu) of the Qing Dynasty for nine years to launch the family's enamel processing career. Songtao is well-known in the field, and one of his works was auctioned for the equivalent of 800,000 Yuan abroad. However, few people in China know him. The sale of cheap enamel products in small commodity markets makes people underestimate the value of cloisonné, and young Chinese people lack understanding of the true craftsmanship.

'They are embroidering on bronze bodies, not satin.'
— Excerpted from Ye Shengtao's prose *Production of Cloisonné*

'Powders of various pigments are mixed with water in dishes that look colorful. It seems as if a painter is working on a painting.'
— Excerpted from Ye Shengtao's prose *Production of Cloisonné*

'Probably because of their proficiency, the craftsman always puts

the right pigment in the right grid, without need to observe the pattern.'

— Excerpted from Ye Shengtao's prose *Production of Cloisonné*

Inheritance

Dianzhuang Filigree Factory is located in a village on the outskirts of Beijing, where Xiong Songtao's grandfather and father lived and worked for decades. The Xiong-Family Enamel Studio was established in 2008. Xiong Songtao, wearing a simple white shirt, says with a smile: "I have stayed here for 40 years and have no intention of leaving. The city is too noisy. It's much better here." Outside the reception room, behind him, is an open space covered with wheat. This is an ordinary factory, nothing different from others in rural areas. However, it produced an extraordinary work, the "Love of the Butterfly" Tourbillon enamel watch, which created a sensation at the Baselworld Watch Fair 2007. Now, this maiden work of Xiong Songtao is worth a million Yuan. At the same time, his craftsmanship has been greatly improved.

The enamel processes are very complicated, including selection of materials, base-hammering, wire inlay, enamel-filling, polishing and soldering. Any mistake at any stage will mar the overall effect, so that the rejection rate is extremely high.

Xiong Songtao explains: "First of all, our enamel products are quite different from the traditional cloisonné in color. We adopt some novel colors and self-made materials. We put some lapis lazuli, turquoise or

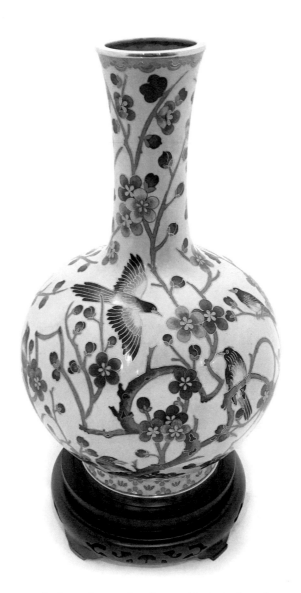

A piece of enamel craftsmanship: Yi Fucheng's
Happiness Tianqiuping Vase.

agate on the glaze made using the traditional royal formula. Second, our wire inlay process is relatively advanced, with the very strong pattern presentation performance. The body is usually made of silver or gold, and copper is seldom used, now. The grinding process is also very exquisite. A dial cannot be finished without total integration of the 54 processes."

After nine years of study in the Royal Workshop, Xiong Songtao's grandfather returned to his hometown and became a farmer to survive amid the turbulence of war. After the founding of the Republic of China, many craftsmen resumed their business in response to the government's call. This helped promote foreign trade, especially export of ornaments. It was in this context that Dianzhuang Filigree Factory was set up, employing about 19 people at that time. Songtao explains: "My grandfather was responsible for enamel making, and my father learned from him while building up the factory. In 2006, I took over this factory from my father."

Like most craftsmanship inheritors, Xiong Songtao has also experienced a lot of suffering and hardships. He spent five years studying how to apply the enamel process to watch dial production, for example.

The dial area is small, and the requirement for accuracy of each linkage is very high. It is quite different from the traditional enamel making process. In those five years, Xiong Songtao made constant attempts to solve the problems cropping up one by one.

Inheriting the enamel craftsmanship with a history of 600 years, he insists on manually applying the 53 stages in making each enamel

product. Pursuing excellence in craftsmanship, he makes constant innovations on the basis of inheriting traditional skills.

At the Baselworld Watch Fair in 2007, he angrily broke his enamel watch in response to Swiss doubts that "Chinese people cannot make such a good enamel watch". This move conquered the doubts of representatives of foreign top-level luxury companies, and helped him win many orders. A few years later, one of the three "Love of Butterfly" Tourbillon enamel watches made by himself was auctioned at a price of 800,000 Yuan, as previously mentioned.

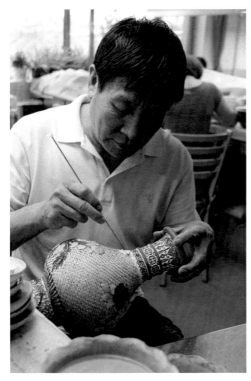

A work photo of the Beijing Arts and Crafts Master Yi Fucheng filling enamel.

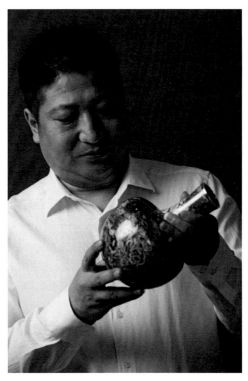

The third generation of enamel craftsmanship of the Xiong Family.

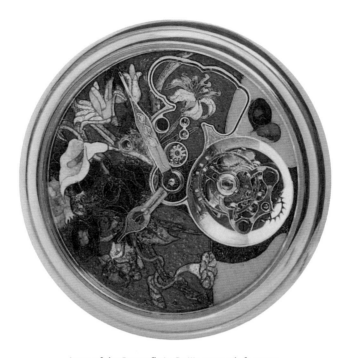

Love of the Butterfly in Beijing watch factory.

Fusion

Although his products sell well abroad, Xiong Songtao feels disappointed because his works of various value and sizes made so meticulously are rarely known and accepted in China.

He says he has ignored many things while devoting himself to research for many years. Now, his biggest goal is to enhance the family brand recognition. "Brand building is necessary to pass down craftsmanship from one generation to the next. The brand and family spirit are vital to ensure a sustainable operation. Nowadays, the idea that 'Good wine needs no bush' seemingly doesn't make sense. Good

Qian Meihua, the first chief artisan of Beijing Enamel Factory, with her final work *He Ping Zun*.

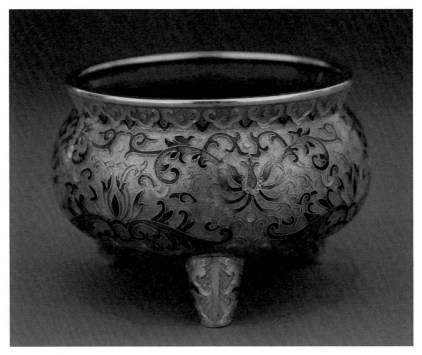

A piece of enamel craftsmanship: Xiong Songtao's *Enamel Tripod Incense Burner.*

craftsmanship also needs promotion."

He is now concentrating on artwork and collectibles, and also plans to set up an Enamel Art Gallery to record, collect and display enamel products. He says: "Enamel craftsmanship has been passed down from my grandfather to my father and to me. I shoulder the mission to carry it forward. Instead of forcing someone to inherit my craftsmanship, I would rather let someone take the initiative to inherit it."

Innovation

"A trend attracts the audience's attention, while traditional things usually fade away in the face of that new trend. Young people are familiar with Swarovski. We are anxious to let more young people know us," he says.

After graduating from college, Xiong Songtao hoped to do his own thing. He was convinced by his father's simple but weighty words: "traditional craftsmanship must be handed down!" After learning for two years, he began to try his hand at creating. Showing great interest in making of enamel watches, he overcame many technical difficulties. In that five years, he broke through the limitations of traditional techniques, reducing the bubbles common in the firing process,

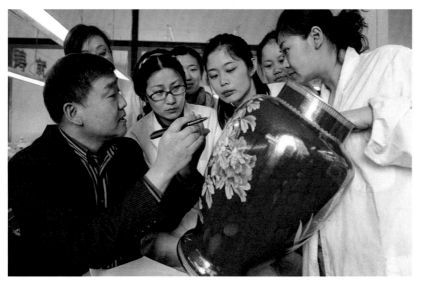

Zhong Liansheng, master of Chinese arts and crafts, directing his apprentice to fill enamel.

introducing new CNC equipment and new technologies, and achieving more precise control of temperature. In doing so, he fell deeply in love with the whole craft.

"Selling of cheap enamel products in small commodity markets makes people underestimate the value of cloisonné, and young Chinese people lack understanding of true enamel craftsmanship." Xiong Songtao hopes to give more people an understanding of the traditional enamel craftsmanship and culture of China.

He observes: "Western countries mainly adopt the process of Champleve Enameling, while China mainly uses the wire inlay process–making patterns using gold or copper wire, filling them with various colors of enamel, and then roasting, grind, gold plating gold, etc. The complexity and retouching of wire inlay reflect the quality of process. A small ornament needs to be processed over a period of two to three months to ensure its quality. We also produce and export enamel jewelry, once making a pair of enamel eardrops at a customer's request, for example. I hope that young people will also know our traditional brand, not only Swarovski."

He goes on: "Sometimes, we encounter difficulties at certain stages. In this context, insistence is difficult but vital. Like enamel, we might change the value orientation with the development of the times, but must maintain our artistic level to avoid losing ourselves. The number of enamel manufacturers has gradually been declining. The enamel craftsmanship of the Xiong family has been handed down so far just because of perseverance."

3.

Dough Modeling Master Changes from Interest to Responsibility

Dough Modeling MasterChanges from Interest to Responsibility

In early 2013, the China Arts and Crafts Association awarded its "Lifetime Achievement Award" to seven folk masters of arts and crafts. They included Feng Hairui, a third generation successor of the art of Dough Modeling. When hearing this good news, Feng Hairui, 78, unexpectedly asked his family: "Can I continue to participate in the exhibition in the future?" Such simple words made them laugh. His attitude towards dough modeling to which he has devoted a lifetime is also simple. Shouldering the responsibility to carry forward a traditional art, he has persevered in dough modeling amid an artistic life far from simple.

The founder of Dough Modeling was Tang Zibo (1882-1971) who began working his craft at the end of the Qing Dynasty. With proficiency in art and studies of Chinese ancient civilization, he learnt widely from the strong points of others and then changed the ways of supporting the dough figurines, developed multiple forms of the craft such as embossment and suspension modeling, and enriched the range of characters, such as scholars, Chinese opera roles and Buddha.

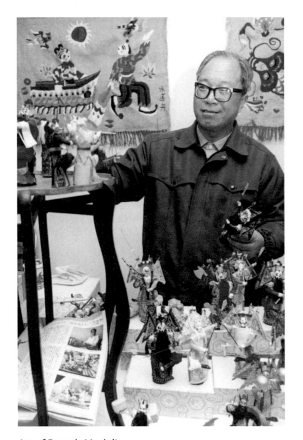

Art of Dough Modeling.

A lot of masterpieces made of flour, pottery, wood, mud, etc., firmly established the status of "Mianrentang". In 1956, the Central School of Arts and Crafts established Tangzibo Studio. From then on, folk dough modeling officially entered the palace of art.

Since childhood, Feng Hairui has loved opera and painting, but more especially the dough modeling art. In 1973, he began to learn from Tang Jinzhang, from the second generation of dough modeling successors. After studying the work of others, he gradually formed his own artistic style. His works look vivid, simple, elegant, colorful but

not vulgar in any way. His masterpiece "Four Great Kings" has been highly praised at many domestic and international exhibitions. Most of his characters are generals and mythical figures. In recent years, he has created multiple groups of works about the customs of old Beijing. His masterpieces such as *Good Harvest*, *Zhong Kui* and *Folk Customs of Beijing*, have been repeatedly awarded at home and abroad. In 1995, he was awarded the title of "Folk Craft Artist" by the Chinese Folk Artists Jury and the Beijing office of UNESCO. In 1995, in the same year, he followed a delegation going to in order to celebrate the French and Portuguese Communist Party Newspaper Festivals to exhibit his works in both countries. In 1996, he participated in the China Artware Exhibition in Japan, undertaking an on-the-spot demonstration of Chinese folk art of dough modeling. In 2005, he was hired as a "Folk Art Creation Researcher" by the Chinese National Academy of Arts.

Dough modeling originates from Heze in Shandong province

The art involves shaping of various images using dough as the raw material. Such figurines first appeared in the Han Dynasty two millennia ago and were used as sacrificial offerings. Through evolution over numerous generations they have now emerged as the collectible dolls seen today.

Dough modeling is a kind of publicly-displayed folk art. This scene can often be seen: A dough modeling craftsman sitting at the streetside opens up his toolbox, takes out a piece of dough and begins to make a doll, the whole process taking only abut 10 minutes.

The art as practiced in Beijing is derived from the "flower offering" popular in Heze, Shandong Province, with reference to some aspects of southern Chinese rice flour dough modeling. At every annual festival, people in Heze hold sacrificial activities, and every household uses colorful steamed noodles to make tridimensional offerings including figures, flowers and fruits, *fulushou* (three lucky gods in ancient Chinese myth), to worship the corresponding ancient gods. Compared to the dough figurines of Beijing, the flower offerings of Heze are much larger. In the capital, you can see some dough modeling craftsmen from Heze skillfully turning flower offerings into dolls on wooden sticks. The dough figurines on wooden sticks often seen in Beijing in the last century all originated from Heze.

In the late Qing Dynasty, some dough modeling craftsmen moved from Shandong to Tongzhou, in the outer eastern suburbs of Beijing. Tang Zibo from Tongzhou, being good at composing poems and painting and being well-learned and versatile, showed a strong interest in dough modeling. He endowed the traditional forms of modeling with new vitality through absorbing elements of traditional Chinese painting art. He changed the support of dough figurines from a wooden stick to plate. Dough dolls were put on cabinets and desks to encourage people's appreciation. Afterwards, Beijing Dough Modeling rapidly grew in fame.

Dough modeling craftsmen must be able to draw figures

Feng Hairui liked dough modeling from childhood. However, he

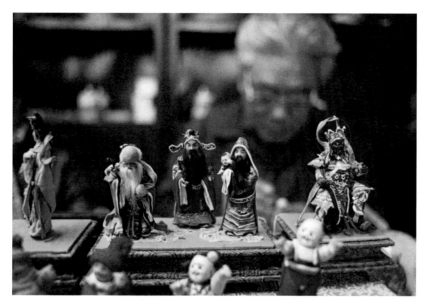

A dough figurine made by Tang Jinzhang, seccond generation successor of the art of Dough Modeling.

was often punished by his parents for spending so much time on this special hobby. However, that didn't discourage his attraction to dough modeling. One time, he was sent on an errand by his parents to buy soy sauce, but ended up following a dough modeling craftsman from Muxiyuan [site of a famous outdoor fabric market in the capital] to Yongdingmen on the northern side of the city, completely forgetting his chore.

In the beginning, Hairui had only interest in the craft rather than any specific skills. In 1973, he was recommended to Tang Jinzhang, who was only two years his elder. At that time, he often went to Tang's home for to learn dough modeling art.

When he was young, Hairui did the pattern design work in Beijing

Printing and Dyeing Factory. Despite strong ability in painting, he could not draw figures. Hence, after realizing the importance of figure painting to the production of dough figurines, he began to learn figure painting. He was determined to become a master in the folk craft, quickly realizing that only craftsmen good at figure painting could create vivid and more beautiful dough figurines. The successors of the art have pursued excellence in both shape and spirit, and what they create are not common dough figurines, but something almost divine.

Since his retirement, he has devoted himself to the study of dough modeling art. He thinks his attainments in retirement are much greater than his work in printing and dyeing earlier in life.

Great art from small tools

The materials and tools for dough modeling seem to be quite simple, but the actual process is complicated. The materials for dough modeling are strong flour and moderately glutinous rice flour, whose mixing proportion can be appropriately set by a craftsman according to his habit and hand strength. Feng Hairui adds relatively little glutinous rice flour into the dough, because too much can easily make the dough brittle in winter. Craftsmen usually like rather soft dough for convenience of modeling, but deformation or downsizing is very likely as a result. Feng Hairui, therefore, opts to go between the two extremes – not too soft and not too hard – which is a matter of careful judgement.

The tools for dough modeling are very common in the main, such as

scissors, combs, bamboo sticks, cone knives, and tweezers. However, the major tool, a modeling knife, is special, looking like a willow leaf, pointed at one end and flat on the other. Holding a piece of dough with his left hand, Feng Hairui performs various operations with a modeling knife in his right. Through unremitting efforts, he finally managed to grasp such intricate skills.

He explains: "Dough modeling is different from clay modeling. In the clay modeling process, clay can be flexibly added, which does not apply for dough modeling. This mainly relies on the hands, rather than a modeling knife. Shaving of the dough from top to bottom is not allowed, because it might make the surface rough. A craftsman of dough modeling needs exquisite skills."

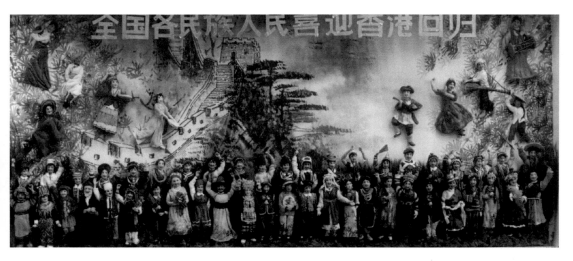

A masterpiece of dough figurine made by Tang Jinzhang to celebrate the return of Hong Kong.

Folklore characteristics and strong Beijing style

Old generations of dough modeling craftsmen were good at drawing Chinese opera characters. Hairui says Tang Zibo liked to make friends with famous opera masters. He asked them to give some advice on his dough modeling performance, which benefited him a lot.

Hairui is a Peking opera fan and also enthusiastic about seal cutting who likes chatting with people about old Beijing. Various hobbies help his dough modeling works look vivid. He initiated a pattern of dough modeling centered on folklore because of one experience. One day, while performing at the Folklore Hall of Dongyue Temple, a Taoist facility in eastern Beijing, he noticed another craftsman making a figurine of the type of briquette stove used in old Beijing. This brought back at memory of an old lady who began telling her grandson about that era when such stoves were in common use. Deeply moved by this scene, Hairui began to study folklore to reproduce living scenes into his works.

Actually, dough modeling centered on folk customs is most difficult. His series of works on the theme of "Folk Customs of Old Beijing" and "Six Teahouses in Beijing" are the most representative, showing various folk customs of Beijing, and reflecting his rich knowledge about life, literature and history. He also reproduced the scene of street sellers selling their cooked meat in the evening in a series of works on "Beijing Snacks". Each peddler selling spicy mutton carried a white cabinet, and each peddler selling pork carried a red or green cabinet. In other words, the food inside the cabinet can be identified just by the color of the enclosing cabinet.

Feng Hairui defines "craft" as the combination of skill and accomplishment. Without accomplishment, a craftsman cannot make lifelike dough figurines. "A craftsman must have ideas and seek to innovate in order to make masterpieces of dough modeling", he says.

Inheritance cannot just be a slogan

Several years ago, Feng Hairui went to Japan on an exchange program. His demonstrations won repeated praise, such as "Great, Chinese culture!"; "So careful, so patient!"

Like most traditional crafts, dough modeling also faces a crisis of inheritance. Feng Hairui is very anxious about this.

In recent years, various districts in Beijing have often organized some activities to spread folk fine arts, inviting some old craftsmen to show the skills of dough modeling and paper-cutting for window decoration in various communities. Hairui often receives such invitations, seeing the activities as beneficial to popularize the dough modeling art and enrich the life of people in the various communities. However, the results are not satisfactory because they tend to attract little attention, and sometimes end up achieving nothing definite. This makes Feng Hairui feel helpless.

He says: "Now, some young people make dough figurines mainly because of interest, but without any responsibility. Few of my students are truly devoted to this cause." Currently, he has only three official students. Under his influence, his daughter Feng Jie is also committed

to the dough modeling cause. She often teaches the children in nearby schools how to make dough toys, helping them learn about the old dough modeling art of Beijing.

Feng Hairui and Feng Jie shoulder the heavy responsibility to carry forward the "Mianrentang" art, hoping it can be passed down forever and continue to bring happiness to a wide audience!

4.

Wax-fruit Making Craft on the Verge of Disappearance

Wax-fruit Making Craft on the Verge of Disappearance

On a summer afternoon, Xiaoshiqiao Lane northwest to the Drum Tower is extraordinarily quiet in stark contrast to the bustling prosperity of the Shichahai district as a whole. Liu Xiuhua, 66, has lived here most of her life. Traces of her wax-fruit making are easily found here. As the only recognized successor of the skill in Beijing, Xiuhua, together with her husband, has been silently devoting herself to the inheritance and development of this craft which has been in the intangible cultural heritage list, but on the verge of disappearing.

Fruit models made of wax involve more than ten steps of traditional craftsmanship. A variety of fruits, vegetables and foods can be made, including apple, pear, peach, banana, strawberry, tomato, bell pepper, cakes and pastries. In the era of material shortage, people often displayed some wax-fruits at home, to add joy and express their yearning for a better life.

Liu Xiuhua has liked painting and model-making since her childhood. In 1971, she was admitted to the Wax-fruit Team within the Traditional Chinese Painting Workshop of Beijing Arts and Crafts Factory, to .

A piece of wax-fruit. Photo by He Luqi

start learning the necessary skills from Ms. Wu Minghua. During that period, she made a variety of models of fruits and vegetables, figures and animals, as well as various kinds of art candles, antique candles, etc.

Unique glory in the era of material shortage

In her home, there are various kinds of fruits including yellow persimmon, crumpled ugly orange, green carambola, fluffy peach, etc. Each is wrapped in a plastic net cover, full in color and luster, and maintaining a bright and attractive appearance. Like true fruits, they look so fine and smooth that people want to have a taste.

"These are all wax fruits hand-made, looking lifelike", says Liu

Xiuhua, taking down a heavy Daoxiangcun gift box from the top of a cabinet. Inside are 10 pieces of newly-made moon cakes of different shapes. The caramel color of the pastry exudes a sweet smell, and the texture of the baking is even reflected in the bottom. She goes on: "Not long ago, a young girl asked me to specially make a box of wax moon cakes. She said she would keep it for passing down the generations."

Liu is very familiar with the history of wax-fruit making since it first emerged in the Song Dynasty (960-1279). At each festival, people always placed some wax lanterns of various shapes such as rabbit, duck, flower and fruit on the river surface. This is the origin of wax-fruit making. In the late Qing Dynasty, in the 19th Century, wax-fruit peddlers began to appear in Beijing. Various types of handicraft workshops were set up after the Qing government was overthrown in the early 20th Century. Among them, "Dejianqiu" workshop (later the Waxwork Factory) in Dongdan Santiao was famous in the wax-fruit making field. After the founding of the People's Republic of China in 1949, the Waxwork Factory was integrated as the Beijing Special Arts and Crafts Production Cooperative, starting to export waxworks to Eastern Europe and the former Soviet Union, while meeting domestic market demands.

"In the 1960s and 1970s, poor transportation conditions made it difficult for northerners to enjoy southern-grown fruits. It took several days to transport Guangzhou's carambola to Beijing by train, for example, so that most of them were rotten by the time they arrived. However, Beijing Film Studio and Beijing People's Art Theatre needed fruits as props, Chinese Academy of Agricultural Sciences also needed plant and fruit specimens for the purpose of research, and the

Academy of Fine Arts needed some teaching models. Wax-fruit played its due role in meeting the various demands", she explains

Liu Xiuhua often thinks of the glory of wax-fruit in the era of material shortage. "In the past, ordinary people often bought wax-fruits for wedding celebrations. They never turned rotten, and were usually put into a display cabinet. They look festive and beautiful."

Persistence in pursuing "excellence" for over forty years

More than a dozen steps are involved in the wax-fruit making process, such as plaster molding, wax liquid preparation, casting, styling, polishing, coloring, etc. It takes at least ten days or even a half month to complete. "Careful work is vital throughout the process. For example, the fruit varieties, Fuji or Ralls, should be selected carefully for verisimilitude."

There is a clapboard shelf that leads directly to the ceiling on the balcony of Liu Xiuhua's house. It is filled with molds of different sizes. There are more than 10 Chinese calligraphy brushes of different sizes in a brush pot. Many colorful pigment bottles are stacked in several layers. There is also an electric soldering iron. She explains: "Patience is needed for wax-fruit making. The model should be dried naturally before moving to the next step."

Although having engaged in wax-fruit making for more than 40 years, Liu Xiuhua has never given up pursuing additional "excellence". In 1971, having graduated from No. 101 High School two years earlier,

she was assigned to the Beijing Arts and Crafts Factory. She recalls: "It was a comprehensive factory comprising a Traditional Chinese Painting Workshop, Jadeware Workshop, Ivory Workshop, Cloisonné Workshop, etc. The Traditional Chinese Painting Workshop also included a Wax-fruit Team, Dough Modeling Team and Snuff Bottle Team."

Liu Xiuhua was assigned to the relatively unpopular Wax-fruit Team, which caused initial disappointment. "At that time, I did feel very disappointed. Except for me, the remaining five or six team members were all elderly. However, I could do nothing but endure." She learned from Master Wu Minghua for three years, recalling, "There were no written teaching materials. I carefully observed and studied my teacher's operations, and gradually started wax-fruit making."

After the painstaking research, she slowly became addicted to this

A piece of wax-fruit. Photo by He Luqi

craft she had once hated, and had the sense of accomplishment emerged as she looked at the life-like wax-fruit products. In 1976, she began to learn traditional Chinese painting from Ning Fuchang, which raised her wax-fruit making skills to a new level. Eight years later, the waxwork workshop was set up, and she was appointed as the person in charge. Besides fruits, human figures and animals also became design objects.

Unfortunately, Beijing Arts and Crafts Factory went bankrupt in 2000, and Liu Xiuhua lost her job. In the following few years, the entire industry declined. She was disheartened, thinking she might have to give up the cause to which she had devoted so much time energy.

Until around 2006, "intangible cultural heritage" protection was officially put on the agenda. Liu Xiuhua suddenly realized her heavy responsibility to pass down the craft of wax-fruit making because the first and second generations of artisan successors had passed away, and Wu Minghua of the third-generation successor was becoming old and powerless.

Difficulty to find a decent site due to limited conditions

Fortunately, her husband Nie Fulin fully supported her in resuming the business at home. She explains: "He was a machinist before. He can help me make some tools, such as the metal funnel for waxing." After working in the family workshop, her husband would often go out to buy raw materials such as plaster and paraffin, driving a motorized tricycle. Sometimes, the children also did them a favor. "It is hard to

buy such raw materials, let alone high-quality ones", she says ruefully

However, she didn't expect to make a living through selling her wax-fruit works. "Nan Luogu Xiang is quite near, but I couldn't afford to rent office space there. Thus, I had to run the business at home." Occasionally, she participates in the exhibitions. She is always willing to carefully introduce her works to anyone showing an interest. "Many people want to see the production process. We are willing to show them. However, there is no suitable platform for us to do so."

Getting older, she is always thinking about how to pass on the craft of wax-fruit making. "Of course, I would like to choose my children first. They both are old enough and can grasp the skills more easily due to my influence." However, they refused to engage in this business despite her repeated attempts. "They can't endure the bitter work. In summer, we have to work in a very hot environment with fire. If some water drops [sweat] gets into the wax liquid, a splashing phenomenon will occur. Finding it hard to make a living from it, they refused my request. I am anxious, wondering who can become my successor!"

After her story was reported by the Beijing TV Station, a young man from Zhejiang province specially visited her with the help of the broadcaster and the local police station. She was moved and unreservedly taught him how to make the molds. "He left two days later because of cost problem. He planned to start business in his hometown. However, he still has a lot to learn."

She says in a tone of regret: "In fact, many people show interest in this craft. I am willing to teach them. However, I can't find a decent venue due to limited conditions." Now her family of three generations live in

a two-bedroom house covering an area of less than 50 square meters. A small wooden table on the balcony is all entire work area. "I dream to have a fixed studio, where the people having interest in wax-fruit making can observe and try it themselves. When it becomes known by more people, maybe someone really loving the craft can be my successor."

5.

Decline of Carved Porcelain Industry in Beijing

Decline of Carved Porcelain Industry in Beijing

Skillfully using an engraving tool, chisel, and wooden hammer, the craftsman gently works out deep or shallow lines on the jade-like and paper-thin porcelain glaze surface. A crisp sound is generated from time to time by such a collision. After staining, the unique wrinkling and rendering effect of a traditional Chinese painting is presented. This is Beijing Carved Porcelain hailed as "embroidery on porcelain". As the third-generation successor of this city-level intangible cultural heritage, Chen Yongchang has devoted 59 years of his life to the craft. Now, well over 70, he is seeking to find qualified successors to carry on the art.

Beijing Carved Porcelain is a plane carving art of engraving patterns of landscapes, flowers, birds and figures on porcelain. It is also a unique ceramic decorative art, integrating elements of calligraphy, painting and sculpture. It expresses the writing skills and features of Chinese calligraphy and painting in a unique way; it also presents a unique artistic beauty and unique visual and touchable texture effect.

Beijing Carved Porcelain artist Chen Yongchang, an ethnic Han, was

born in Beijing in 1941. In 1957, he began learning porcelain carving from his father, Chen Zhiguang. As the third-generation successor of the craft, he has exquisite skills, and his works mainly portray flowers, birds, landscapes, as well as current affairs. Through more than 20 years of unremitting efforts, he has developed an innovative product, the "snuff bottle engraved inside". He uses a unique porcelain carving tool to engrave patterns on the inner wall of a glass snuff bottle through its mouth with a diameter of about 5 mm. This craft is really unique. His representative works include "Heavenly Road" and "An Old Man Picking a Chrysanthemum" engraved on porcelain dishes, "Tiger" engraved on a porcelain bottle, and "Much Distress Regenerates a Nation" engraved on a porcelain plate.

History of Beijing Carved Porcelain

It is said that carved porcelain first emerged in the Eastern Jin Dynasty (317-420). However, the unique porcelain art was not truly formed until over a thousand years later in the late Ming Dynasty. There are many different versions about its origins. According to legend, an emperor of the Song Dynasty liked to sketch some celebrities' paintings and calligraphy works on porcelain. Worried the colored drawing on the porcelain might fall off, he ordered his ceramic craftsmen to outline the colored drawings with knives, so as to preserve them for a long time. From then on, carved porcelain gradually became popular.

According to another legend, Qianlong, an 18th Century Emperor of

the Qing Dynasty, often wrote poems on his favorite porcelain. He ordered court artists to find a way to preserve his works indefinitely. Finally, ceramic craftsmen did manage to engrave them on porcelain, thus launching a new art.

The whole point is to engrave on a porcelain glaze. Presumably, carved porcelain originated from carved jade originally used to decorate and beautify the porcelain. In the Qing Dynasty, craftsmen began to outline the works of literati on porcelain, which achieved the perfect combination of porcelain with literature, and promoted the development of carved porcelain art. During the reign of Emperor Guangxu (1875-1908), a unique style of carved porcelain art was formed by the famous craftsman Hua Yuesan from Shanghai, who engraved the poems and patterns of landscapes, flowers and birds on a white porcelain glaze. In 1902, Shuntian (supreme authority) opened the Arts and Crafts School under the Ministry of Agriculture and Industry, inviting Hua Yuesan to teach the carved porcelain course. Among more than 20 students, Chen Zhiguang stood out and finally became his successor.

At that time, Chen Zhiguang had a classmate, Zhu Youlin, his elder by two years. During their three years of study together, they established a profound friendship, becoming lifelong friends.

In the last years during the reign of Emperor Guangxu, turbulence and mass impoverishment dominated Chinese life. After graduation in 1907, all students, except Chen Zhiguang and Zhu Youlin, drifted away in search of other ways to make a living. They undertook porcelain carving work in a porcelain shop along the west side of Qianmen

[south of Tiananmen Square]. Chen Zhiguang was good at elaborate-style painting, while Zhu Youlin specialized in the study of freehand brushwork. They worked together to make many achievements in porcelain carving.

Unique weapon: a "diamond cutter"

As a Chinese saying goes, "when a workman wishes to get his work well done, he must first sharpen his tools." At that time, southern craftsmen used tungsten steel knives, while northern craftsmen preferred combined use of carving knifes, chisels and hammers. However, the effect was unsatisfactory, and the lingering charm of traditional Chinese painting could only be expressed inadequately. Therefore, they decided to design an efficient tool on the basis of

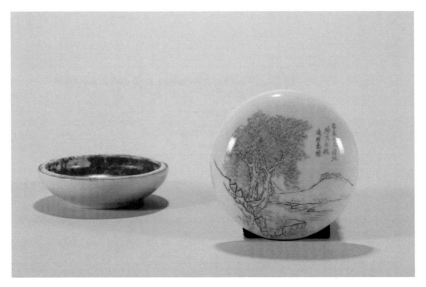

A piece of carved porcelain.

absorbing the strengths of southern and northern craftsmen.

As the saying goes, "if there is no diamond, do not get porcelain living." A special tool inlaid with a diamond was used for pottery repair at that time. Diamond is harder than porcelain, and can easily leave traces on the porcelain glaze. Knowing this, the two craftsmen invented a "diamond cutter" composed of a diamond (equivalent to half a grain of rice) and a copper rod as thick as a ballpoint pen refill.

This tool was much more expensive than the ordinary tools available at that time. Its production was time-consuming, especially the cutting and installation of the diamond. The rejection rate was very high, reaching almost two-thirds. Use of this special "diamond cutter", however, achieved flexible, smooth outlining, and also the desired effect far better than before. This tool became their "unique weapon".

Reunion 40 years later

After hard work for seven years, Chen Zhiguang and Zhu Youlin achieved dissatisfactory results. In 1914, Chen Zhiguang left the Qianmen porcelain shop to make a living in another field elsewhere. After serving as a postal train guard for some time, he went to Shanghai, where he began to engrave exquisite brush flower-and-bird paintings on ivory, and gradually accepted apprentices. However, he did not impart the craft of porcelain carving.

At that time, Zhu Youlin in Beijing gradually stood out among the capital's porcelain carving craftsmen, and carved porcelain became

one of Beijing's three major treasures. His works won numerous awards at home and abroad, and he created a number of fine works through extensive cooperation with Chang Dai-Chien (1899-1983) and other Chinese painting masters. In December 1935, the Secretariat of Beijing Municipal People's Government published the book *Cultural Relics of Old Beijing*, which introduced Beijing Carved Porcelain. Beijing Carved Porcelain reached the height of its popularity at that time.

In 1954, Chen Zhiguang returned to Beijing from Shanghai. He first worked in a private ivory factory, and then engaged in plane carved designs in Beijing No.2 Ivory Production Cooperative. In 1956, Beijing Special Arts and Crafts Industry Co., Ltd. planned to established the Research Institute of Arts and Crafts. A number of old artists including Chen Zhiguang and Zhu Youlin were employed. Thus, after a break of more than 40 years, the two masters finally reunited.

Concentration required for porcelain carving

Porcelain carving is an art integrating elements of fine arts and engraving. The basic steps include drawing, engraving, chiseling, staining, etc. Commonly-used tools include carving knife, steel chisel, bamboo pen and hammer. A certain degree of painting knowledge and carving skill are needed for better porcelain carving.

In 1957, the 16-year-old Chen Yongchang, only child of Chen Zhiguang, was recruited by the Research Institute of Arts and Crafts. On the first day, his father taught nothing about theory and painting,

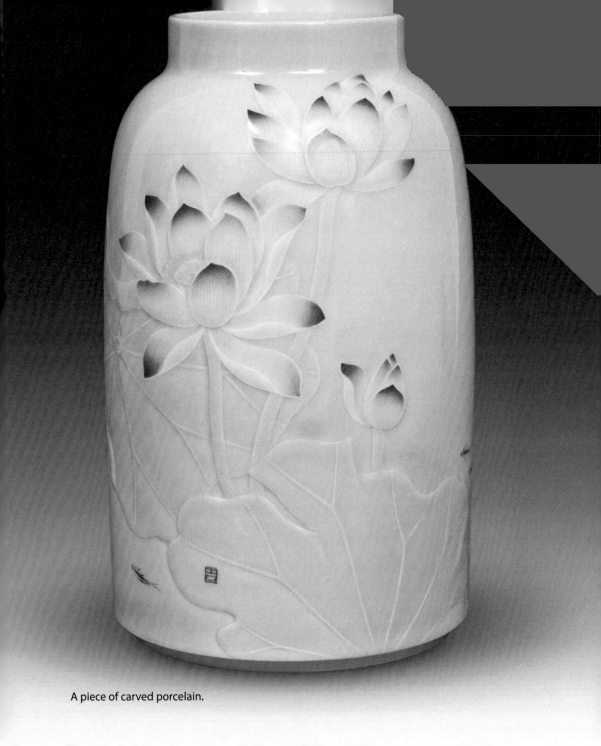
A piece of carved porcelain.

but gave him a carving knife and a porcelain pen holder, saying: "You must learn to engrave lines first."

Line engraving is the basis of porcelain carving, and is also the most difficult and boring link in the process chain. Porcelain glaze is jade-like and thin as paper. As the porcelain surface becomes curved somewhat, it is difficult to flexibly engrave lines. Before engraving, a craftsman must adopt a very high degree of concentration. Then, he should engrave slowly and carefully on the glaze surface with the appropriate strength. Finally, soft and delicate lines composed of very fine dots will be formed.

In addition to the diamond knife, a chisel is often used. The craftsman usually holds the chisel with three fingers of his left hand, and evenly strikes it with a little hammer in his right hand, to create the pattern with similar wrinkling and rendering effect of traditional Chinese painting. This is the traditional process of Beijing Carved Porcelain. However, the process advocated by Chen Zhiguang is slightly different: A small wooden strip is gently clamped with two fingers of right hand, to facilitate control. Painstaking efforts are needed to grasp each skill of making Beijing Carved Porcelain. For example, it took Yongchang more than a month to attain some skill in line engraving. If the engraving strength is not proper, the porcelain might be destroyed.

Unpromising Beijing Carved Porcelain

After three years of learning, Chen Yongchang became the third-generation successor of Beijing Carved Porcelain. Many old artists

have since passed away, and Chen Yongchang is also becoming old. As an older-generation artist who grew up with China's reform and opening up, he has experienced many ups and downs. Now, he has three basic wishes.

First, he wishes to create more works for future generations. Nowadays, he creates one piece on average every year, and the works are basically collected at his home. He explains: "I preserve them for future generations."

Second, he wishes to publicize the true Beijing Carved Porcelain. Now, many people are engaged in porcelain carving in Beijing, but their works are not true products of the old craft. A diamond knife and a steel chisel are used to create Beijing Carved Porcelain with the similar ink painting effect, which is the biggest feature. However, the effect shown by use of a chisel is similar to that of sketch.

Third, he wishes to pass down the unique craft to suitable successors. The art cannot be grasped in a short term. He is willing to teach students free of charge for one year. However, few people show interest.

His requirement for apprentices is persistence

In recent years, Chen Yongchang has created countless works, but he never promotes them. So far, only one of his works has been sold, and all others are preserved at his studio.

In 2011, he was invited to showcase his output at a cultural exhibition

A piece of carved porcelain.

of intangible cultural heritage works. An old gentleman showed a great interest in his carved porcelain plate with a landscape pattern. "In the beginning, I told him that it wasn't for sale. Noticing he really liked it, however, I asked him to come again on the last day of exhibition," Chen Yongchang recalls. Sure enough the man turned up at the appointed time and his persistence created a sale. Chen says: "I and my wife are not commercially minded. Relying on a monthly retirement pay of three or four thousand Yuan, we can make a living. There is no need to sell my works for a living."

Now becoming aged, however, he is thinking about the successor issue. "My son once learned the craft of porcelain carving, and my daughter followed my wife to learn the craft of making dough figurines. However, they both have their own work, without intention to becoming a fully-fledged successor." Five or six years ago, a middle-aged couple from Shandong province visited Chen Yongchang, hoping to learn skills from him. He said: "With the experience of art teaching, they understood and grasped skills quickly. I heard that they have developed well in their hometown." He was delighted to talk about these two apprentices. He taught them without reservation and charged no fee.

In 2014, Xicheng District launched the "Endangered Intangible Cultural Heritage" protection plan, and the project of openly recruiting successors of Beijing Carving Porcelain was launched. Chen says: "Five candidates would be recruited for each project. Ten of more than one hundred applicants were chosen after examination, in consideration of their painting experience. They received 24 class hours of intensive training in the Intangible Cultural Heritage Center."

Regrettably, only the post-80s girl Zhou Xiaoming passed the last test. Chen says: "I attach much importance to persistence. Young people are smart, but are always eager to succeed immediately. This girl is engaged in ceramic design, and really loves this craft. I don't mind whether I have few or many apprentices."

At the same time, he gives lectures in an elementary school every Wednesday. He explains: "I teach for more than ten class hours per semester. In one hour each time, children learn to engrave under my guidance." Half a year later, he found that half of these students gave up. However, he didn't feel frustrated: "Forced inheritance of craftsmanship is not attractive. Fortunately, the project of promoting the intangible cultural heritage in schools will make more children learn about the porcelain carving art. This is also a kind of inheritance."

6.

Court Art Beijing Embroidery

Court Art Beijing Embroidery

As one of the eight treasures of Yenching (former name of Beijing in olden times), Beijing Embroidery, if we compare it with cloisonné, carved lacquer, royal blanket-making and inlaid gold lacquer, was closer to the royal family. For example, dragon robes worn by emperors were invariably made through the application of Beijing Embroidery.

Also known as "Royal Embroidery" or "Court Embroidery", this is a general term for embroidery products of areas forming the city of Beijing, with northern folk embroidery as a basis. It is a kind of time-honored traditional embroidery of the Han ethnic group reaching a peak in the Ming and Qing Dynasties, and was mostly used for court decoration and clothing. Reflecting exquisite skills and elegant styling, Beijing Embroidery made of high-quality materials reflected the wisdom and artistic creativity of ancient artisans. In 2014, it was included in the national intangible cultural heritage list.

Yu Jing is a representative successor of Beijing Embroidery representing the intangible cultural heritage of Haidian District in

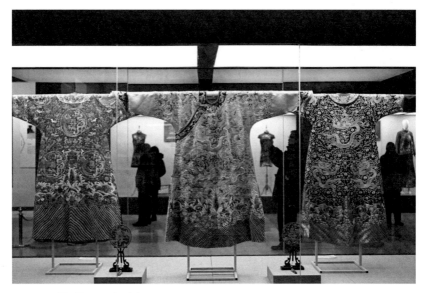

A piece of Beijing embroidey.

northern Beijing. She graduated from Beijing Institute of Fashion Technology, majoring in fashion design. She has shown a special interest in Beijing Embroidery since childhood, and, since 2004, has been committed to the design and production of articles integrating traditional embroidery techniques with original creativity. So far, she has developed 15 categories of Beijing Embroidery products, and designed more than 600 different patterns. She is a supplier of gifts for the State leaders, overseas embassies and consulates of China. She has won many honors, such as second prize in the National Dress Grand Prix, the Gold Award of Beijing Gifts, first prize in the Embroidery Skills Competition for Beijing Workers, second prize of Beijing Design Week, and second prize of the Beijing Arts and Crafts Cup.

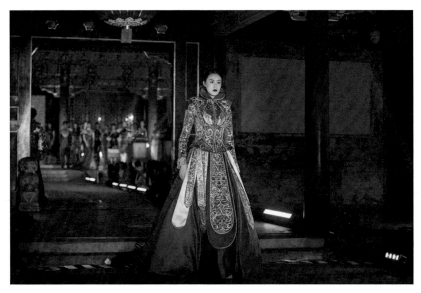

A piece of Beijing embroidey.

Inheritance of Beijing Embroidery through the generations

The history of Beijing Embroidery can be traced back to the Tang Dynasty (spanning the 7th to the 10th centuries), reaching its peak during the Liao Dynasty in northern China (907-1125). Records show an embroidery workshop was specially set up in Yenching during that period to serve the clothing needs of the royal family and nobles. Beijing Embroidery was described in the Records of Khitan written during the Southern Song Dynasty: "A northern city is very prosperous, where a wide variety of products are available. There are a lot of Buddhist temples there. The embroidery there is well-known and unique."

In the Yuan Dynasty (12th and 13th centuries), Cannetille was

preferred for Beijing Embroidery, which also became known as "Pingjin Dazi" embroidery. Its process was very complex: hammering gold foil, twisting numerous threads and forming patterns. Made of precious raw materials, "Pingjin Dazi" embroidery products are very delicate, showing the luxurious lifestyle of the royal family. This special embroidery process was rarely seen in other regions. After the Ming Dynasty, Beijing Embroidery became increasingly distinctive in its raw materials and patterns. The Qing Dynasty marked a peak in its prosperity. During the reign of Emperor Guangxu spanning the late 19th and early 20th centuries, it was well-known at home and abroad, and dozens of embroidery workshops emerged in Beijing. The embroidery street in Xihuying, Hebao Lane, outside Qianmen (southern gate of the imperial palace), became a gathering place for its craftsmen.

Exquisite Beijing Embroidery — symbol of the royal family

Beijing Embroidery is mainly characterized by elegant, exquisite and flexible embroidery, beautiful patterns and vivid images. With silk as the major raw material, the clothing looks very valuable, luxurious and beautiful. The process of Beijing Embroidery is unique, involving the design of patterns based on Cannetille, and fixing it with colored lines. Each Beijing Embroidery product reflects the royal style, looking brilliant, precious and rare. All representative works of the genre display the great authority of the royal family and the nobility.

Beijing Embroidery is very prominent in three distinct aspects. First,

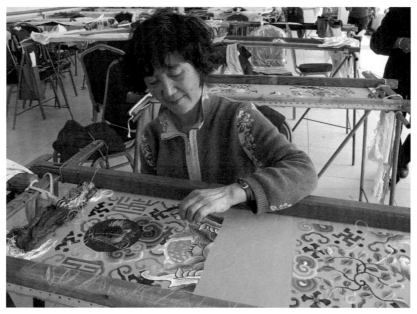

Sun Ying, an intangible cultural heritage successor of China is doing the embroidering work.

it has a unique status. For example, some patterns such as the Twelve Ornaments and five-clawed golden dragon pattern, could only be used for the emperors. Second, patterns cover a wide range of topics such as landscapes, flowers and birds, dragons and phoenix, fowls and beasts, and the Eight Auspicious Symbols, which all have the implied meaning of "being especially auspicious". Third, with the strong court art style, gorgeous decoration and rare raw materials, some embroidery products are decorated with agate, jade or other gems in key areas. Beijing Embroidery nowadays is mainly used for making stage costumes of Beijing opera, ancient costumes for special events, and costumes for movie and television plays. In particular, 80 percent of traditional Beijing opera costumes are embroidered.

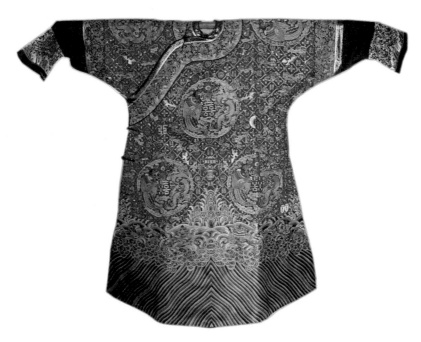

A piece of Beijing embroidey.

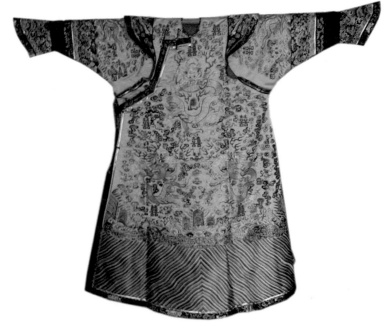

A piece of Beijing embroidey.

Art inheritance for love

However, Beijing Embroidery is on the verge of disappearing, so that it becomes an urgent necessity to protect and continue to develop it.

As the representative successor of Beijing Embroidery, Yu Jing is running a company customizing advanced products related to the genre. In fact, her relationship with the craft can be traced back to the era when her great grandmother was alive.

Beijing Embroidery flourished in the Ming and Qing Dynasties. As the influence of palace embroidery art expanded, the people in Beijing followed suit.

This lady, Yufeng Qingzhu, was a Manchu woman living in the Qing Dynasty. At that time, women were required to learn needlecraft, especially embroidery. She was particularly outstanding in this regard so that, after marriage, she and her family engaged in the business of shell fabrics and embroidery located near a glass factory in Beijing.

Yu Jing recalls: "I have liked Beijing Embroidery since childhood. I remember that their cuffs had piped embroidery patterns and look so beautiful." She was particularly impressed by the embroidery patterns of clothes worn by the elder female in the family.

Her mother and grandmother also did some embroidering work as part of their daily life, which gradually influenced Yu Jing, who unconsciously was falling in love with the work.

In her company, you can see some Beijing Embroidery works that she created, as well as some framed necklines and cuffs with special

embroidery patterns cut from the old clothes of her own female elders.

Due to love of art and clothing, she started systematic study of fashion design in the Beijing Institute of Fashion Technology. After graduation, she went to Shenzhen and began her career as a fashion designer.

In 2003, she began to customize the products related to Beijing Embroidery, combining her hobby with her major.

Fusion of tradition and modernity

She encountered many difficulties in the early stage when she urgently needed workers of traditional Beijing Embroidery and found them hard to find.

However, modern Beijing Embroidery is an endangered art, and there are few Beijing Embroidery successors carrying on the traditions of the older generations. In the initial post-liberation period, Beijing Embroidery Factory was established, which was mainly export-oriented. However, with its gradual decline, many Beijing Embroidery craftsmen drifted away into other professions.

"Fortunately, I successfully persuaded some workers still working there to come and work for me", she says, so the talent problem was eventually solved

Now, her company provides customized Beijing Embroidery products for a number of China's embassies, government departments and

enterprises. She is very proud that Beijing Embroidery has gone global.

She thinks that, with the development of the times, a fusion of tradition with modern artistic aesthetics, and constant innovation, are needed to guarantee a better inheritance of Beijing Embroidery.

"The costume patterns classic in the past might be out of date in these days. Innovation, rather than blind copying, is required for the development of Beijing Embroidery", which she believes should conform to the current era's requirements.

The "phoenix and peony" pattern is adopted in many works of Beijing Embroidery. A wide range of patterns have the implied meaning of "being auspicious".

According to legend, the phoenix is the king of birds, and the peony king of flowers. The combination of phoenix and peony symbolizes richness, light and happiness. Her tippet works embroidered with the "phoenix and peony" pattern have been designated as national gifts many times.

Her tippet and handbag works embroidered with the "phoenix and peony" pattern show the perfect combination of tradition and modern aesthetics.

She also actively to promote innovation. In addition to tippets, glasses, boxes, wallets and other products of Beijing Embroidery are produced by her company. "We can make any product related to Beijing Embroidery", she says proudly. The elements of Beijing Embroidery can be integrated into daily necessities including sofa cushions, chair

cushions, bedding, home furnishing, clothing, etc.

In regard to the inheritance and development of Beijing Embroidery, she insists that, "any successor should always make corresponding changes according to the changes of the times".

Passing down for future generations

On November 11, 2014, Beijing Embroidery was approved by the State Council to be included in China's fourth intangible cultural heritage list, marking the increasing attention to inheritance and development of the special craft.

Yu Jing now teaches a Beijing Embroidery course at the Beijing Industry and Trade Technicians College. Of this activity, she says: "If several of my students can do the work related to Beijing Embroidery after graduation, I will feel it has all been very worthwhile."

She thinks creation of Beijing Embroidery products does not depend on techniques and experience, or use of threads and colors. More importantly, artistic literacy should be improved.

Beijing Embroidery mainly served the royal family in the past. Many people today understand Beijing Embroidery mainly through dragon robes and vestments that they see in TV and stage performances of historical dramas, but it's much more complicated than that. Says Yu Jing:

"Stage costumes of Beijing Embroidery seem to be very brightly colored, which is people's general understanding. However, Beijing

Embroidery works preserved in the Forbidden City or Beijing Museum are very soft in color."

She thinks that Beijing Embroidery is artistic in color matching. Besides embroidery skills, artistic accomplishment and design ability should also be given priority. Like the cook mentioned in the book *Health Lord* by Chuang-tzu, a 4th Century BCE philosopher, Beijing Embroidery craftsmen should be able to skillfully use the elements of music, Chinese calligraphy and painting.

In order to better pass on the skills of historic Beijing Embroidery, Yu Jing and Professor Chen Li at Academy of Arts & Design, Tsinghua University, jointly compiled a textbook on it. This proved a very difficult process, and they encountered difficulties in data collection. However, through painstaking efforts for more than a year, they managed to finish its compilation.

In the eyes of Professor Chen Li, Yu Jing is particularly brave and hardworking. Despite difficulties, she has engaged in running the business of Beijing Embroidery for more than a decade. Summing up her work, she says firmly: "Beijing Embroidery will accompany me forever!; I will make Beijing Embroidery go global." In the past decade or so, she has been devoting herself to the fashion design of traditional Beijing Embroidery, again stressing that, "traditional patterns cannot be simply copied, but should be innovated according to modern aesthetics and fashion elements. Every era has its features and highlights, which should be reflected in works".

7.

Cao Kites Still Soar in the Sky

Cao Kites Still Soar in the Sky

People are hurrying to and fro in Shichahai, Beijing, a bustling area where there are many bars and small restaurants, along with an important commercial street. Still there are corners of tranquility, including Sanshizhai Kite Shop owned by Liu Bin, a third-generation successor of traditional Cao Kites.

"Few people truly know about kites," insists Liu, who for has made a living for years from his kite craftsmanship. Kites may seem very familiar to everyone, but, actually, the vast majority have little knowledge in actual fact.

The four chief skills of Cao Kites involve the design and construction, pasting, painting and then the actual flying. Practitioners must have certain skills in fine

Long-string kites

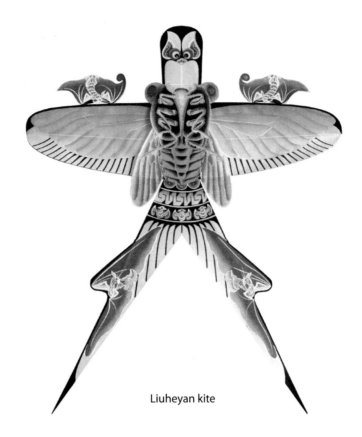

Liuheyan kite

arts, carpentry and photography. It takes about 1-3 days to build a kite skeleton following the adoption of a pattern having a modern or classical sense or cultural connotations and creativity. With the continuous prosperity of the tourism product and handicraft markets, creative development of kites remains a key demand.

Cao Kites are divided into royal, temple and folk versions. The kites sold in Sanshizhai are the royal version.

Liu Bin, born in 1977, is the successor of Cao Kites as an intangible cultural heritage of China. In 2005, he founded Beijing Liushi Sanshizhai Kite Culture Communication Center to spread the

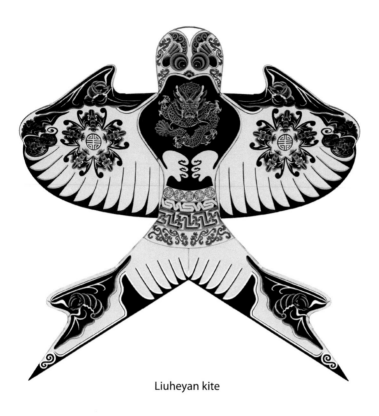

Liuheyan kite

longstanding kite culture of China. During his childhood, he followed his grandfather Liu Huiren to learn the skills of making court kites. From 2006 to 2009, he studied the craftsmanship of making the temple version from Tang Jinkun. And, since 2009, with help of Mr. Kong Lingmin, he has been learning the skills of making Cao Kites of both the royal and folk versions.

Since mastering the traditional kite-making process, Liu Bin has been committed to integrating modern computer art and patterns of various genre into his designs in order to enhance the artistic value of kites. In 2010, at the request of the National Ballet of China, he designed kites

called "Blue and White Porcelain", which were presented to China's embassies around the world. In 2012, he went to Kenya for engage in cultural exchanges and presented the kite "Wulongyan" to the Kenyan government. He has performed his skills in and visited many countries and regions such as the U.S., Austria, Czech Republic, Hungary, and the member states of ASEAN. The kite art with Chinese cultural characteristics he is promoting has been highly praised.

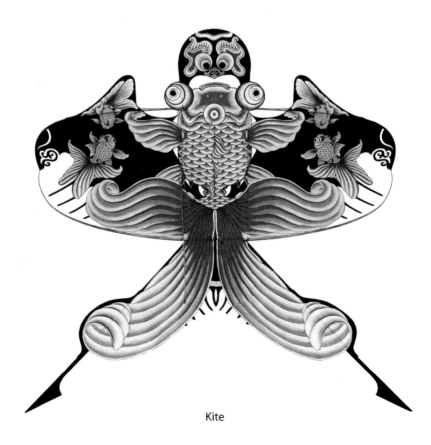

Kite

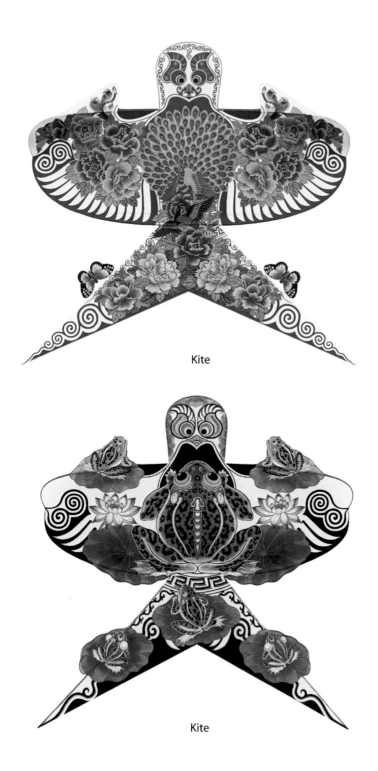

Kite

Kite

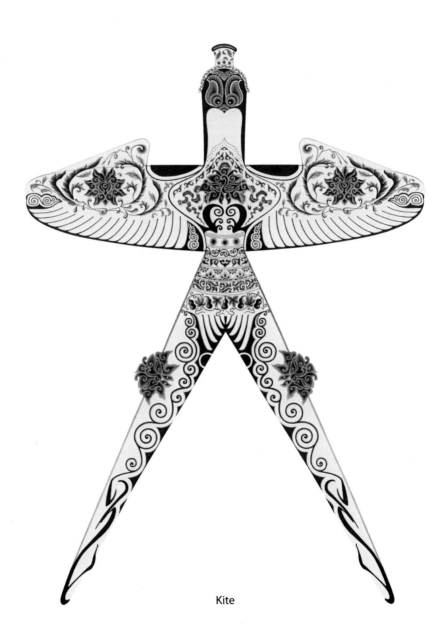

Kite

Kite skills described by Cao Xueqin

The history of kites can be traced back to the Spring and Autumn Period and the Warring States Period some 2,400 years ago. An ancient record states that, "Luban cut bamboo into a magpie shape, and then made it fly". This is the first known reference to a kite. In fact, early kites were mostly used for military and communications purposes. Around the time of the Tang Dynasty and Five Dynasties well over a millennium ago, the kite gradually became an entertainment tool for ordinary people.

The name of Cao Xueqin is best known as that of the author of A Dream in Red Mansions. In fact, he also wrote two books about kite craft.

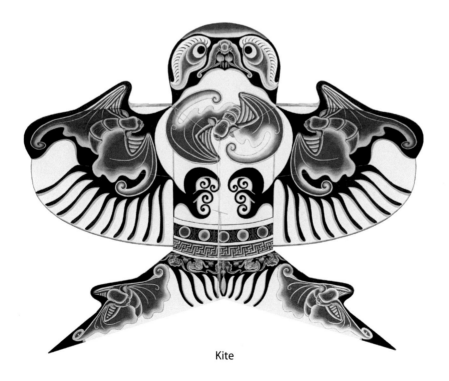

Kite

He had a friend named Yu Jinglian. After becoming disabled during a military expedition, Yu asked for Cao's help to make a living. The latter taught him the craftsmanship of making kites achieving that particular purpose. Cao Xueqin thus had an idea to help poor people with a disability to survive. To this end, he wrote the book *Nanyao Beiyuan Kaogongzhi.*

To further promote this cause, Cao later wrote the book *Feiyichai Jigao* comprising eight volumes, including those about the carving of gold/stone stamps, kite making, weaving and dyeing, carving of bamboo products and fan ribs, garden construction, cooking, etc. *Nanyao Beiyuan Kaogongzhi* is the second volume of *Feiyichai Jigao*, in which the author painted the patterns of kites passed down and designed by himself, and compiled easy-to-understand verses expounding the skills of making, pasting, painting and flying his designs.

In 1943, a young man majoring in painting and sculpture at the National Peiping [Beijing] Art Academy, experienced an unforgettable event.

For the purpose of research and learning, his Japanese teacher Takami Hiroto borrowed a copy of *Feiyichai Jigao* from a Japanese businessman. Realizing it was written by Cao Xueqin, Hiroto hired some cultural relics experts and artists to authenticate and copy it, a project that was completed in 26 days. The aforesaid young man then got involved. However, that particular book was bought by a Japanese businessman and has never been heard of ever since.

The young man in question was Kong Xiangze, now aged 96. He is

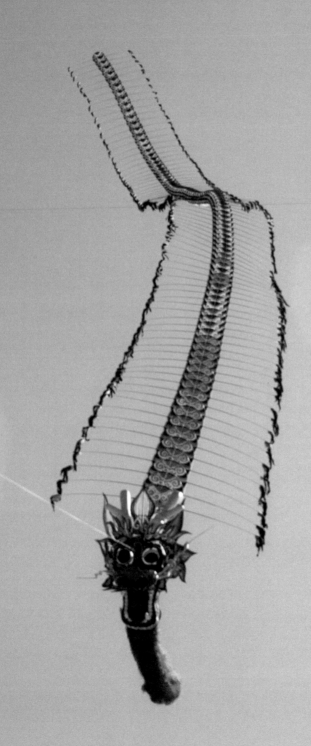

Kite

Kite

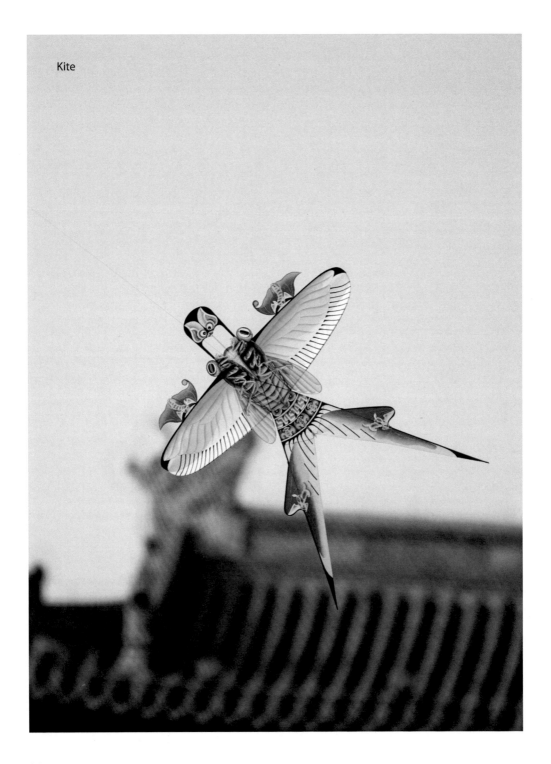

the father of Liu Bin's teacher, and also the only living person to have seen the copy of *Feiyichai Jigao*.

Nanyao Beiyuan Kaogongzhi systematically records the various aspects of kite manufacture and flying. After careful study of it, Kong Xiangze created the unique craftsmanship of Cao Kites.

As indicated by their formal names, Liu Bin says, kites were designed respectively for the royal family, monks and ordinary people. Later, this craftsmanship was spread to the port city of Tianjin not far from Beijing.

Cao Kites are the folk version. Liu Bin's grandfather was a craftsman of royal-version kites, and Liu Bin's first teacher was a craftsman of temple-version kites in Tianjin. Liu is proud of having grasped the skills of making kites in all three versions, which has strengthened his determination to pass down the traditional craft.

He says that, every year, more than 2,000 foreign guests visit his store and try their hand at making kites by themselves. However, few young Chinese people today are willing to study this craft. "I only have one apprentice, who is 70 years old." During a theme event to cultivate the intangible cultural heritage successors some time ago, more than 10 young people expressed their intention to learn this craft. "However, no one contacted me after the event", he says with sadness.

Kites with features of both entertainment and art

Liu Bin has had a close tie with kites since childhood. He still

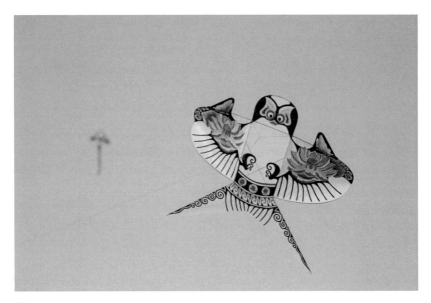

Kite

remembers the time he and his grandfather flew a dragon-shaped kite more than 100 meters long over Tiananmen Square in the heart of the capital. His grandfather suggested he study the art as his college major.

"Over the years, I successively grasped the skills of woodworking, decoration, painting, calligraphy and design. All these skills are used for the making of kites." Today, however, he sees the craft having little future, adding, "It is easy to make a kite fly, but is difficult to make a kite with high artistic value."

Many "skeletons" of kites hang from the roof of Sanshizhai Kite Shop. According to Liu Bin, bamboo for making a kite must be air-dried first to make the best skeleton when it becomes oily. "I bake each of my kites first and then dry it for a year before use."

The patterns and shapes of kites are all personalized. For example,

the head-to-shoulder ratio of the most classic kite shaped like a "bank swallow" is specially set. Generally speaking, if the ratio ranges between 11:1 and 9:1, it indicates the swallow is female; if the ratio ranges between 8:1 and 6:1, it indicates a male; if it is 5:1, it means the swallow is young. Liu Bin then goes on to explain the differences in more detail. If the ratio is 6: 1, it indicates it is a "boy"; if the ratio is 7:1, it means it is a "young adult". In addition, the patterns and shapes of wing, tail and other parts are specially designed.

However, despite the painstaking efforts of Liu Bin and older generations, corresponding returns are barely achievable. Although gaining a gross profit of 200,000 Yuan a year, Liu ends up with virtually nothing after deduction of various expenses.

According to him, most people regard kites as toys worth "dozens of Yuan at most". However, in his eyes, each kite is "an artwork".

"The pace of social development is too fast. People seemingly cannot calm down", laments Liu Bin, who stresses that kite making needs great resilience, and there are now few such talents around.

New exploration based on technology

Liu Bin is often confused about his identity. "I am a craftsman, but also a businessman", which he sees as contradictory to a certain extent. It is time-consuming to make quality products, but mass production is needed for making profit.

He describes the cost problem he faces. "It takes at least one day to

make the skeleton of a sand-swallow-shaped kite. In consideration of a labor cost of 200 Yuan per day, and other expenses, it should be priced at 300 Yuan at the very least."

In order to reduce costs, Liu Bin continues to experiment. He uses computer printing technology for kite making, which not only increases production, but also reduces costs. "Most importantly, computer printing technology makes it possible to refine the product in some aspects." The patterns, especially those of small kites used as ornaments and souvenirs, are difficult to be replicated manually with the high accuracy required.

His peers have questioned his use of technology, but he insists: "Technology is only a means, and design is the soul. Computer printing and manual operation roughly account for 80 percent and 20 percent of total workload respectively. Thus, a lower time cost means the price is naturally reduced."

In the Sanshizhai Kite Shop, there are also many creative kites designed by Liu Bin to cater to the tastes of modern people, such as ones shaped like western "dragon", a cyclist, sand swallow, etc.

"Before passing away, my grandfather solemnly required me to pass down the craft", he recalls. In the eyes of Liu Bin, Sanshizhai Kite Shop is a place where he takes over the kite making craft from his grandfather. No matter how difficult the task, he will never waver on the road of inheritance.

8.

Painted Sculpture of Peking Opera Facial Makeup

Painted Sculpture of Peking Opera Facial Makeup

Just as its name implies, painted sculpture of Peking Opera facial makeup emerged after the emergence rise of this particular opera genre. However, before the appearance of Peking Opera facial makeup, the painted clay sculpture industry was already enjoying a boom in Beijing. At that time, there were the time-honored Nuo Mask, and other handicrafts with some similarities to masks and facial makeup that were closely related to people's life.

Painted sculpture of Peking Opera facial makeup emerged about 1894. It is said to have been invented by a person with the surname of Gui who was good at writing poetry and painting and was very fond of Peking Opera. He made a face-shaped mold with clay, dried it, and then painted it according to the style of facial makeup demanded in Peking Opera. Because he mainly painted hualian (a male character in Chinese opera with a painted face) he was called "Hualian Guizi". From then on, clay sculptures with facial makeup became popular in the capital.

Lin Hongkui from Beijing is the fifth-generation successor of this

particular art form listed as a city-level intangible cultural heritage. His mother is Tong Xiufen, an acknowledged master of opera masks. Influenced by his family background, Lin studied painting and the creation of painted sculpture adopting Peking Opera facial makeup in his childhood. On the basis of inheriting the tradition, he innovatively designed a makeup style according to the facial forms of Peking Opera masters. In 2015, he was hailed as one of "China's Young and Middle-aged Literary and Art Workers with Both Professional Excellence and Moral Integrity".

Revealing the inward-looking world of characters

Facial makeup of traditional opera has evolved through the establishment of many traditions related to an actor's face. Facial makeup is generally used for *jing* (male character with a painted face) and *chou* (clown). The patterns and colors of facial makeup are specifically designed for different characters to highlight their personalities. Simply by observing the facial makeup, the audience can visually judge whether a character is good or evil. Thus, facial makeup is known as "that able to reveal the inward world of various characters".

Peking Opera facial makeup is an art very much cherished by traditional opera fans, and is widely acknowledged as one of the symbols of China's ancient culture. Facial makeup mainly involves contradiction and unity between beauty and ugliness, close relationship with the character, and stylized patterns.

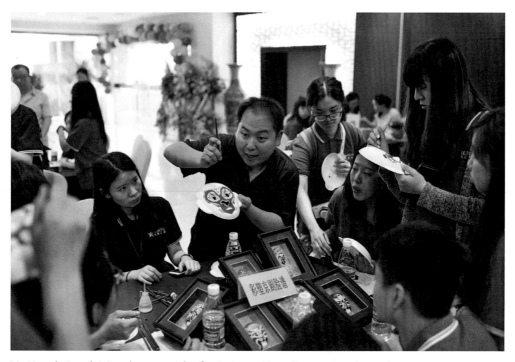

Lin Hongkui explaining the essentials of painting to Hong Kong university students.

The colors of Peking Opera facial makeup are specially designed to personalize each character, and not simply for the purpose of beautification. According to the facial makeup, opera insiders can distinguish whether a character is supposed to be heroic or evil, smart or stupid, beloved or creating a sense of disgust.

Colors generally have the following meanings: Red generally indicates positive, loyal and brave characters such as Guan Yu [a legendary general serving a warlord in the second century]; black generally refers to upright, straightforward and selfless characters such as Bao Zheng [Song Dynasty official in the 11th Century]; white generally represents sinister and crafty characters such as Cao Cao [a warlord living between 155 and 220]; yellow refers to brave and feral characters; a

golden coloring generally indicates immortal or exceptionally talented characters.

The expression in the eyes and face can reflect a person's emotions and psychology. Similarly, facial makeup can arouse the audience's aesthetic psychology. Although facial makeup has relatively independent appreciation value and aesthetic significance, it is fundamentally an integral part of the opera performance. Artistic expression and aesthetic characteristics of facial makeup cannot be fully understood and understood by the audience without close observation of costume and performance.

Well-designed facial makeup

As previously stated, painted sculpture of Peking Opera facial makeup derived from the development of this particular representative opera genre. In the beginning, clay sculptures of facial makeup emerged. Later, a plane painted facial makeup was invented before the final emergence of embossed clay sculpture of facial makeup. Afterwards, handicrafts based on embossed clay sculpture of facial makeup were invented, undergoing a gradual change from simple to complex, from plane to three-dimensional, and from single to a complex production process, variety and coloring. This can easily be understood by studying the varieties of painted sculpture of Peking Opera facial makeup.

The first kind of clay sculpture of facial makeup was achieved on an embossed mold, which is colorful, showing all the sensory organs,

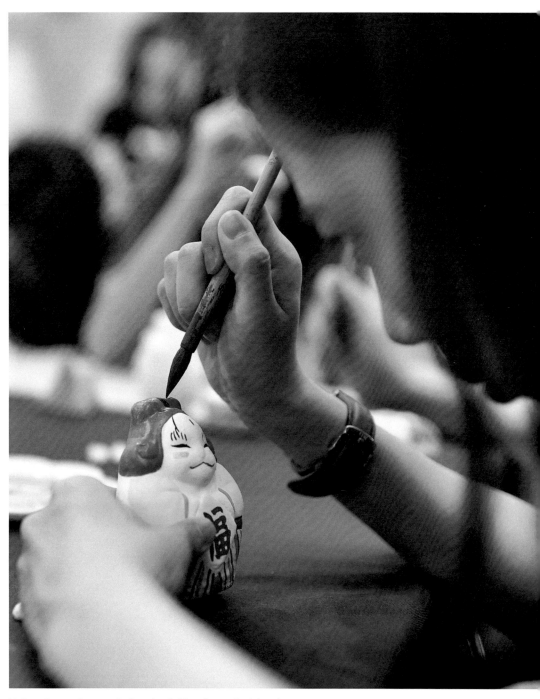

University students painting the Peking Opera facial makeup.

but without artificial whiskers or adorned with a helmet. This was the prototype of clay sculpture of facial makeup. Through years of refining, processing and beautification, it is still popular.

The second kind is painted, having both a beard and relatively simple headwear.

The third kind is based on a typical and representative scene of traditional opera, with multiple facial makeup patterns, opera highlights, or main representative characters. Later, to meet demand, clay sculpture objects were expanded from the original *jing* to *xiaosheng* (young man's role) and *qingyi* (main female role).

In the 1980s and 1990s, painted sculpture of Peking Opera facial makeup, which had a helmet that was downsized according to the real one, was invented. It's time-consuming, but the finished product is very exquisite and beautiful.

Destiny of connection with painted sculpture of Peking Opera facial makeup

Post-80s, Lin Hongkui's destined connection with painted sculpture of Peking Opera facial makeup is closely intertwined with that of his mother Tong Xiufen as the representative successor. Lin recalls: "Few toys were available when I was young. Some clay and plaster molds became my toys. One time, I presented a facial makeup work to celebrate the birthday of one of my classmates. Later, many classmates asked for gifts from me, which gave me a sense of accomplishment."

Thus, he gradually felt the charm of painted sculpture of Peking Opera facial makeup.

However, he didn't really develop it into a full business operation until 2009. Instead of receiving specialized, systematic education about painted sculpture of Peking Opera facial makeup, he mainly learned art appreciation and associated skills from his mother. At college, he mainly took computer courses, and only painted facial makeup clay models in his spare time. In 2007, painted sculpture of Peking Opera facial makeup was chosen to be listed as an intangible cultural heritage. In 2009, Xicheng District Intangible Cultural Heritage Protection Center was established in Beijing. These two initiatives made Lin realize anew the vitality of painted sculpture of Peking Opera facial makeup. He says: "At that time, the industry of painted sculpture of Peking Opera facial makeup was stagnant. I decided to help my mother better pass down this craft to future generations."

Innovation and inheritance with new ideas

It was his strong opinion that, in order to better pass on the craft, it had to be developed, innovated and endowed with new connotations a line with the changes of the times. Without a market and public recognition, it could never survive. He has gained an understanding of how to enable more people to understand the craftsmanship and cultural connotations of the genre.

In 2010, Lin began to try making painted sculpture of Peking Opera facial makeup with cartoon-style figures (four models, each 17 cm

high), such as Guan Yu carrying a knife, and Zhong Kui [legendary queller of demons] trampling on goblins. He explains: "Cartoon-style modeling reflects the innovation based on original facial makeup patterns, which aims to attract young people. Next, we will develop the derivative products of facial makeup patterns of famous Peking Opera masters, including bookmarks, refrigerator magnets, postcards, etc., to highlight the elements of Peking Opera and make it become a representative cultural and creative tourism product of Beijing and even the whole of China." The series of facial makeup products he has developed according to the facial makeup patterns of Peking Opera masters are divided into two kinds – collectable and used as ordinary gifts – that, to a certain extent, broadens the market appeal.

In order to give a wider audience an understanding of understand painted sculpture of Peking Opera facial makeup, he and his mother have visited many schools in Beijing, Taiwan and American cities like San Francisco, where they introduce the intangible cultural heritage project, and personally demonstrate the production process and facial makeup painting process. Lin also designs the online multimedia courseware, to make painted sculpture of Peking Opera facial makeup "come alive". Facial makeup works portraying various characters, reflect the essence and profundity of ancient Chinese art. "I hope more people can understand and like facial makeup", he says.

Creating more possibilities

As the successor of painted sculpture of Peking Opera facial makeup,

Lin Hongkui has established his own cultural company. Besides protection and development of this intangible cultural heritage, he is committed to helping a wider range of traditional cultural products go global.

From 2012 to 2017, he and others acting as successors of the craft participated in handicraft art fairs at home and abroad, and undertook some intangible cultural heritage protection projects. At the end of 2015, the authorities in Jerusalem invited Lin and others to design seven streetscapes with themes of different countries, including China, Russia, Japan, and Brazil. In January 2017, he undertook the project involving the "Happy Spring Festival" exhibition in Washington, and selected 10 successors and six intangible cultural heritage genres for the Beijing Art Troupe including the snuff bottle engraved inside, painted sculpture of Peking Opera facial makeup, Beijing Zongren (bristle figure), Beijing Paper-cut, Beijing Dough Figurines, and Beijing Sugar Painting.

He says: "I think the intangible cultural heritage protection industry is very promising, and I am willing to contribute to its further development. I hope more people can get involved to better pass down and develop the traditional crafts."

9.

Rich Connotations of Beijing Snuff Bottle with Internal Painting

Rich Connotations of Beijing Snuff Bottle with Internal Painting

Snuff Bottle with Internal Painting is a small glass bottle inside which countless historical figures and their stories are be portrayed. Such a bottle, introduced to China only as a utensil in the beginning, gradually became endowed with cultural connotations and magical techniques, and thus constituting part of traditional culture. Yang Zhigang is the fourth-generation successor of the Beijing Snuff Bottle with Internal Painting who is shouldering the mission to pass down this traditional craft.

This particular craft has undergone clear evolutionary process. Snuff in two kinds of square bottles with an external golden flower pattern, was introduced to China by Westerners in the late 16th Century during the reign of Ming Dynasty Emperor Shenzong. At that time, snuff bottles looked so simple and common. However, two centuries later, the Snuff Bottle with Internal Painting made an amazing entry to center stage so that "common" snuff bottles quickly lost that dismissive tag.

Yang Zhigang, born in 1963, is the fourth-generation successor of the

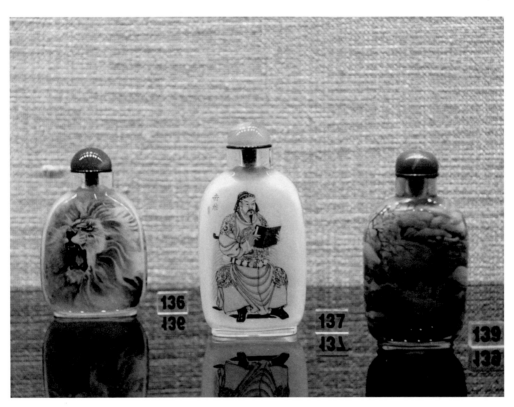

Sep 13, 2015, Beijing Snuff Bottle with Internal Painting Exhibition in the Capital Museum, Beijing. Photo by Jin Wen

craft. In December 1981, he was admitted to the former Beijing Arts and Crafts Factory, where he learned the internal painting process from a famous master, Liu Shouben. His masterpieces include *Three Warriors' Fight with Lv Bu, Five Ghosts and Zhong Kui, All the Pretty Horses, Chang'an Lantern Show, Preface to the Orchid Pavilion, Sets of Pots as Souvenirs of Hong Kong's Return to China, Chinese Famous Tower*, and *Three Visits to the Hut*.

Now aged 52, with short spiky hair and wearing short sleeves and bracelets, Yang sits in front of his workbench, holding a crystal pot less than 10 cm high with his left hand, and pinching a tailor-made elbow brush with fingertips of his right hand. By skillfully using the elbow brush passing through the narrow mouth, he gradually inscribes lifelike patterns of landscapes, flowers, birds, and figures on the inner walls.

Snuff Bottle with Internal Painting has been included on the national intangible cultural heritage list. Soon after graduation from senior high school in December 1981, Yang Zhigang started to study its intricacies in the Beijing Arts and Crafts Factory. Now, he is a hoary-headed veteran.

Beijing Snuff Bottle With Internal Painting once Konwn as "Ghost Painting Pots"

Now an acknowledged master himself, he advocates traditions, and tradition seemingly is always surrounding him. In fact, of course, snuff is an imported product.

"Just as its name implies, this is a bottle for containing snuff, and an appendant", he says. The custom of snuff taking was originally formed in America. In the great navigation era of exploration, ships carried snuff around the world. As a tribute, snuff was introduced to China in the late Ming Dynasty and early Qing Dynasty. Its production process is complicated. Made of good tobacco leaves, mint, borneol and other medicinal materials, snuff has to be sealed in a cellar for years before it can be used. It was usually contained in metal boxes like those used for holding cigarettes.

During the reign of the Qing Dynasty emperors Kangxi and Qianlong, particularly during the period of the latter, exquisite snuff bottles were created by the Royal Workshop. Under this influence, snuff bottles of various shapes like Chinese medicine bottle shape began to emerge in Beijing. Raw materials include enamel, jade, ivory, etc. The processes in manufacture include outer carving, outer painting, hollowing, inlaying, etc. The crystal/glass Snuff Bottle with Internal Painting represents the highest artistic level. In the old days, some superstitious Beijingers mistakenly thought exquisite patterns on the inner walls of snuff bottle were drawn by ghosts and gods, so they were also called "ghost painting pots".

The earliest extant snuff bottle was made during the reign of Emperor Jiaqing (1796-1820), and is collected in the Princeton University Art Museum. As tobacco (smoked in a long-stemmed Chinese pipe) and shredded tobacco for water pipes became popular in the late Qing Dynasty, snuff gradually lost its practical value. In the following period of nearly half a century, the development of snuff bottle art was almost stagnant.

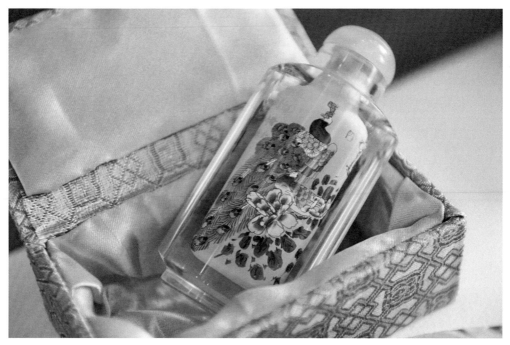

Apr 28, 2017, Many intangible cultural arts and crafts in the exhibition room, Zhuanta Hutong, Xicheng District, Beijing. Photo by Wei Yao

In the 20th century, foreign artwork practitioners began to pay attention to snuff bottles, and the Snuff Bottle with Internal Painting was once again recognized by the world as something unique. In 2007, it was included in Beijing's first intangible cultural heritages; in 2008, it was included in the list of Chinese intangible cultural heritage list.

PRC recruits folk craftsmen for arts protection

After the founding of the People's Republic of China, artwork factories began to recruit folk craftsmen to protect traditional arts and crafts. At that time, the skills involved in the Beijing Snuff Bottle with

Internal Painting created by Ye Zhongsan, one of the four masters of the art in the Qing Dynasty, were passed down. His two sons, Ye Xiaofeng and Ye Bengqi, were invited to work at the Beijing Arts and Crafts Institute, which promoted the inheritance and development of the craft. Later, part of the Institute was incorporated into Beijing Arts and Crafts Factory.

In 1981, Yang Zhigang was admitted to the facility after his graduation from high school. He and a woman student took first place in the factory entrance examination, and were assigned to the internal painting section of the jade workshop.

Reverse painting is needed to produce this unique product. Exercises in paintbrush dexterity is the premise to grasping the challenges of this craft. As Yang explains: "This is very different from our traditional way of writing and pen-holding. When writing, we keep the pen/pencil tip and the line of sight moving synchronously in the same direction. This is contrary to the method adopted for reverse painting conducted inside the snuff bottle."

On the first day of work, Yang Zhigang saw his master Liu Shouben wearing a white gown. There were only a dozen employees in the internal painting workshop at the time. He started learning the simplest skill of delineation with a snuff bottle base, brush, ink and inkstone. Three months later, after repeated exercises, he was ultimately recognized by his master. Looking at his first delineation work, *Goddess Chang'e Flies to the Moon*, his master told him: "Color it".

Generally, it should have taken two years to complete the apprenticeship. However, Yang Zhigang needed only half a year

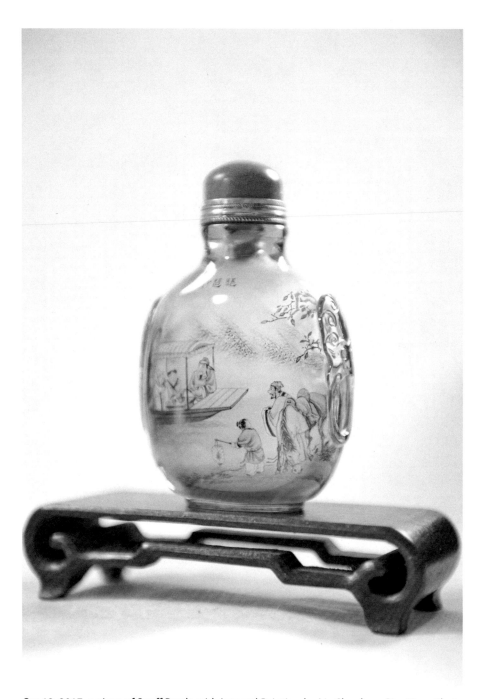

Oct 13, 2017, a piece of Snuff Bottle with Internal Painting by Liu Shouben: *Pipa Xing*. Photo by Wei Yao

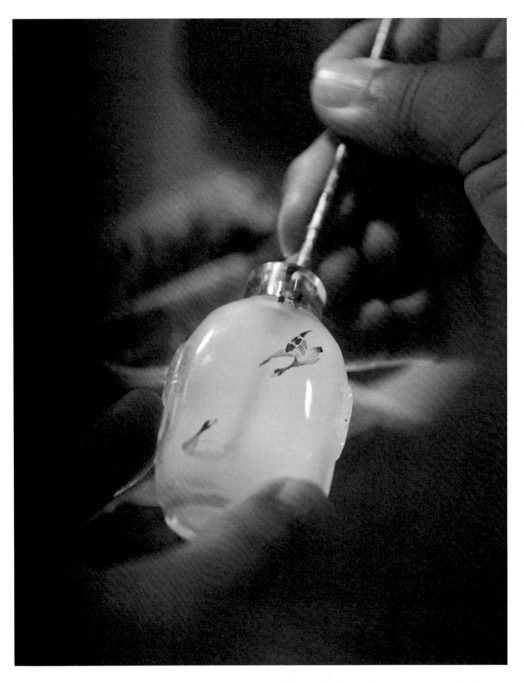

Liu Shouben, the successor of the Beijing Snuff Bottle with Internal Painting, is working. Photo by Tian He and Wang Yu

due to his interest, talent and painstaking efforts. For further self-enhancement, he always went to evening school after work from 1981 to 1991. He recalls: "I did not systematically learn painting courses before. To improve my painting skills, I took various fine arts courses at evening school." Due to his painstaking efforts and persistence, he stood out among the many apprentices, assisting Liu Shouben in creating a lot of internal painting masterpieces such as the crystal snuff bottle with the internal painting of *Chang'an Lantern Show*, which was awarded the first creation prize of the National Arts and Crafts Award by the Ministry of Light Industry in 1986.

Skill in painting is obviously of prime importance. Before entering Beijing Arts and Crafts Factory, Yang Zhigang had received no formal painting education. He explains: "At high school, I was responsible for editing the blackboard newspaper, almost knowing nothing about sketches, oil paintings, traditional Chinese paintings, etc. A solid painting foundation, of course, is vital to mastering internal painting skills." In the 1980s, many universities in Beijing opened free evening schools, which became the best places for him to learn painting. From 1981 to 1991, he studied many basic techniques related to internal painting, such as sketching, coloring, traditional Chinese painting figure foundations, calligraphy, seal cutting, etc.

Registration as an intangible cultural heritage

In 2003, Yang Zhigang was laid off in the context of a sluggish arts and crafts industry and enterprise restructuring. With no desire to

leave the field of arts and crafts, he started a jade carving business while still retaining a love for the Snuff Bottle with Internal Painting. One day in 2005, one of his leaders of the former Beijing Arts and Crafts Factory asked him to apply for registering the Snuff Bottle with Internal Painting as a national intangible cultural heritage in response to a call from the State. He immediately put away his work, beginning to concentrate on preparing the registration application. "In the past, I thought that making of a Snuff Bottle with Internal Painting was just my job, paying little attention to the historical stories my master often told me. However, after much research, I suddenly realized the precious nature of this craft, and the profound cultural connotations behind it. I shoulder the mission to pass on this craft."

In 2008, the Snuff Bottle with Internal Painting became a national intangible cultural heritage. In 2009, his master Liu Shouben became the successor of this craft. The success of listing application reaffirmed his determination to pass down this craft.

Every day, Yang Zhigang practices the skills of his craft, and studies the history and culture behind it, as well as ways to further improve the internal painting brush. He takes out about 20 inner painting brushes from two small boxes on the table behind him, and introduces them one by one. "When a workman wishes to get his work well done, he must have his tools sharpened first. Through years of research, I have developed these metal pens. Each pen is composed of a silver point, a copper sheathing in the middle, and a piece of hardwood in the end. These bamboo pens, copper pens and brushes were developed in the earlier period." These painting tools, through his improvements, reflect his determination and efforts in passing down and continuing to

develop the Snuff Bottle with Internal Painting.

"Now only five or six people in China can make the Snuff Bottle with Internal Painting."

At the age of 52, Yang Zhigang currently mainly engages in research, exhibition and promotion, and only occasionally makes a new Snuff Bottle with Internal Painting. However, he never overcharges, and his crystal snuff bottles are generally priced at about 10,000 Yuan.

"Now, the snuff bottle industry of a certain size has taken shape in Hebei, Shandong and places, rather than Beijing. Including myself, only five or six people in China can make the Snuff Bottle with Internal Painting. Among us, I am relatively young." He said the several major schools of the craft all originated from Beijing.

Yang Zhigang is the fourth-generation successor, but a fifth-generation successor is still unknown. Great calm is needed for the craft, which is seemly incompatible with modern society. "In olden times, craftsmen passed down their crafts only to family members by kinship degree to enable them to maintain a better life. Now, we hope to pass down the craft of the Beijing Snuff Bottle with Internal Painting. It takes two years to complete an apprenticeship, but an even longer time to earn money. Thus, few young people are willing to engage in this work. What we can do is to look for pre-destined people."

So, what is the best way forward ? The project of promoting the intangible cultural heritage craft in schools enables Yang Zhigang able

to better promote understanding: "We have signed agreements with some universities in Beijing to give lectures regularly each semester. For example, we opened a three-month training class on the Snuff Bottle with Internal Painting in Beijing Union University not long ago. At present, some primary and secondary schools ask me to give lectures to help their students understand the craft and the stories and culture behind it." These activities can play a certain promotional role, but it is far from enough in Yang's eyes. He says: "Learning how to produce a Snuff Bottle with Internal Painting is a long process. A short-term experience cannot make people really understand this craft and the culture behind it. To make more people willing to learn this craft and better pass down it, we still need to overcome difficulties in many aspects. "

Yang Zhigang tells the story about the charm of this traditional craft: "As my master once told me, the Snuff Bottle with Internal Painting reflects both royal culture and civilian culture."

10.

A Brick Carving Artist in the Capital

A Brick Carving Artist in the Capital

'Each man has only one genuine vocation to find the way to himself ... and live it out wholly and resolutely within himself. Everything else is only a would-be existence, an attempt at evasion, a flight back to the ideals of the masses, conformity and fear of one's own inwardness.'

— *Demian* by Hermann Hesse

With a time-honored history, Beijing brick carving falls into two categories: relief and openwork, both featuring exquisite workmanship. As a kind of outstanding architectural ornament with strong ethnic flavor, they are widely used to decorate the gateway, corridor, tracery wall, screen wall, window and the like of old buildings. Patterns of brick carvings include flowers, animals, figures, and calligraphy. Topping the list of the four major brick carving arts in China, the Beijing variety thrived in the Ming (1368-1644) and Qing (1644-1911) dynasties, deeply influenced by royal culture, thus featuring an obvious imperial style. The emperor in the Ming Dynasty

first gathered together skillful craftsmen in various fields across the country build a new capital city of outstanding style. By virtue of superb carving skills, the brand of "Brick Carving Zhang" was well established. It was listed in Beijing's intangible cultural heritage list in 2009.

As the only representative successor, Zhang Yan has been exposed to the brick carving art since childhood. When he was eight, his father began to teach him some basic skills such as carving the lacework, grooving and brick grinding. After entering junior high school, the boy was able to independently carve flowers, birds and animals. In university, he focused on the study of traditional Chinese painting and achieved very good results. However, as a son of a brick carver, this

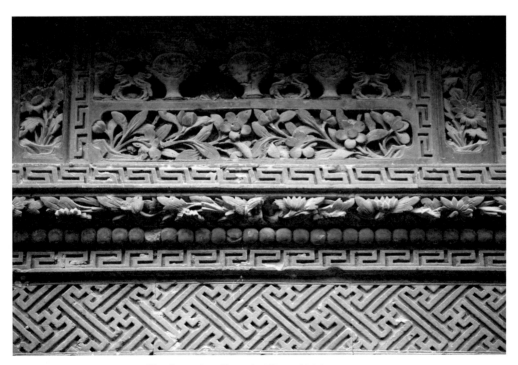

A piece of brick carving. Photo by Zhang Kaixin

was his greatest love.

In the early summer of Beijing, it is still a bit cool in the eastern suburbs. The rows of houses and empty streets creation an illusion that "this is not Beijing". Those occasionally appearing in the street are mostly old people.

For us who have got used to the bustling city life, the quiet here is really something unusual. However, for a brick carver, this may actually be an ideal place for him to concentrate on his career.

Pushing open the low and shabby red gate, you will find that most of the yard is occupied by black bricks stacked neatly or scattered randomly here and there, while the remaining part is the working area on which stands an extremely simple shed built with plastic sheets set against the wall. A black brick engraved with the words "Master Studio for Beijing Brick Carving Zhang" can be seen on the wall.

A modern family Sticking to an ancient art

"When compared with brick carvings in other regions, the carving craft in Beijing obviously shows something unique of the royal taste because of its close relationship with the capital city", Zhang Yan explains calmly. He is the only representative successor of Beijing brick carving recognized by the municipal government.

Brick carving is a craft to which Zhang's family has been dedicated for more than 200 years. Zhang Yan is the sixth-generation successor. In the past two centuries, no matter how things changed, the Zhang's

A piece of brick carving. Photo by Zhang Kaixin

family has remained attached to the carving knife, black bricks and their love for brick carving.

Along with the inheritance of the brick carving art, stories of brick carving involving those forefathers have also been passed down from generation to generation.

The Zhang family has lived on architectural sculptures, painting and clay figurines for generations. In the 18th century, Zhang Shangzu, an artist engaged in dragon and phoenix carving, was called to the court to help with the creation of a beautiful capital city, specifically focusing on the carving works in the royal garden. In this way, the Zhang's family began its career in the capital, and Zhang Shaozu became the founder of Brick Carving Zhang in Beijing. From then on, sons chose to follow in fathers' footsteps to work for the royal family. Zhang Tingxiang, the third-generation successor, rose to fame as a brick carving artist in his youth. He spearheaded an effort to carve furniture following the style of the Ming Dynasty, which is really something unprecedented. Zhang Tingwu was famous for carving the dragon, phoenix and other auspicious beasts. Besides, this family also invented the carving tools including the butterfly shovel and bat knife. All these combined to lay a solid foundation for the development of the Beijing brick carving style. The nickname of "Brick Carving Zhang" has since then been well known to the public. The fourth-generation successor, Zhang Dejun, set up a firm known as "De Ming Ge" at Dashilan Street in East Beijing in his later years to sell brick sculpture and renovate the traditional quadrangle courtyards. After the founding of the Republic of China in 1912, Zhang Shiquan, the fifth-generation successor, struggled to keep the business going amid a

succession of civil distances and wars.

Now, the sixth-generation successor is Zhang Yan, a big name in the circle of brick carving in Beijing. His works have the most salient features of Beijing brick carvings: grandeur, magnificence, nobility, being well-aligned, and well-composed, displaying the unique local culture and architectural charm of the capital city. Zhang has been recognized as the only successor of "Beijing brick carving project" by the municipal government.

"When I was young, I remembered that, no matter how tired he was after a day's hard work, my father would hide himself away in a hut to carve at night." Zhang Yan was no more than six at the time. Out of curiosity, he followed father to the hut stealthily, discovering his father's "secret" through a crack in the door.

"A few moments later, a beautiful peony flower appeared on the brick", he recalls. In the flickering light of the kerosene lamp, the father seemed to be surrounded by a dazzling aura. "He is like a deity in my heart because he can easily turn black bricks into various auspicious birds, flowers and animals …"

After that, Zhang Yan began to look forward to the moment when his father went to carve in the hut every night. At the outset, the boy just trailed behind to peek from outside. However, soon he was not satisfied with this. He wanted to go inside, but his pleas were rejected by the father. He didn't give up and begged repeatedly. His father had to give in, but warned him not to "let the cat out of the bag" to others. "This craft was forbidden then, which I didn't understand until I became an adult."

A piece of brick carving. Photo by Zhang Kaixin

In this way, the father carved in the hut every night, and his son would stand by him, watching him at work. Gradually, the father realized his son was really loved brick carving, and it was not just acting not on a whim. Finally, the father asked: "Do you want to learn carving?" Zhang Yan recalls, "I just remember that I nodded heavily. Father replied, 'if you want to learn, you can begin with rubbing bricks. Smooth their surface.' After these words, he continued to carve and didn't say anything more."

In those days, Zhang Yan never tired of asking his father to repeat those stories about the ancestors. One night, sitting on the edge of the bed, the father began to recall the past of the family as usual. He got somewhat depressed and couldn't help sighing, "you belong to the new era. I'm not sure whether the carving craft in our family can continue

A piece of brick carving. Photo by Lin Hongsheng

to be passed down or not." Zhang Yan immediately responded: "Dad, I'll do it." He was 12 that year.

The promise Zhang Yan made to his father was fulfilled in the end. After finishing study of traditional Chinese painting in the university, he returned home and concentrated on learning brick carving from his father. Looking back at the previous generations and then at himself, Zhang Yan thinks they all tried their best to continuously carry forward the carving craft the family had relied on for a living for generations.

"In the 1980s when the country began to introduce the reform and opening up policy, everyone was busy in making money, but I stayed at home to learn brick carving. What's more, people then had little knowledge about the craft. They felt confused and insisted that I was nothing but a chairwarmer." No market means no income. Zhang Yan had to temporarily turn to house painting for a living. However, when he was able to make ends meet, he returned to his brick carving.

Concentrating on development of brick carving in the great new era

It was not until 1999 that things began a turn for the better. Some artists Zhang Yan met when working on interior design showed interest in his brick sculpture. They bought some as decorations and at the same time, they also brought some new customers to him. Along with the first national large-scale survey for intangible cultural heritage and the subsequent publication of the intangible cultural heritage representative list, the public began to know more about the traditional

carving craft and show some preference for it. The market for Beijing brick sculpture picked up little by little as a result.

"Although the market is still not so prosperous, I can do the job without distractions, and I don't have to worry about bread-and-butter issues every day", Zhang Yan says with a smile.

As to market demand, he has always strictly adhered to the carving techniques left behind by his forefathers and at the same time, he is also willing to try something new to keep pace with the times. However, he never hesitates to refuse what he considers improper and unreasonable requests from customers. He is very clear what brick carving means. For a brick sculpture, what can be done, what cannot be done, and how to do it, all these must be based on established rules. No mistakes are allowed. "Make the right choice and do it well."

In recent years, what has worried him most is the inheritance of the craft. His children have been fully exposed to the carving art since childhood, but they haven't completed their studies at school. As he gets older, Zhang Yan is increasingly eager to have apprentices focusing on the traditional craft. and at the same time, he can better understand his father's fears in those years.

Taking on apprentices is different from inheritance within the family. The biggest difference between the two, Zhang Yan thinks, lies in responsibility. "Enthusiasm alone is far from enough. Quite a few apprentices gave up halfway because they couldn't resist the temptation from their peers with much bigger incomes."

"What I can do is to provide accommodation and food. In addition

to covering their living expenses every month, I can also ensure they'll have some extra money to bring back to home at the end of the year. I just want to create a favorable environment in which they can settle down to studying. Even so, some apprentices still choose to leave every year." In teaching, Zhang Yan goes all out to stimulate his apprentices' interest in Beijing brick carving, which, he thinks, is the best way to retain those who truly love and are willing to devote themselves to the craft.

Currently, in addition to training apprentices, Zhang Yan will also regularly give lessons in elementary schools, high schools and universities for the popularization of the carving craft. Very proudly, he shows off a brick sculptures produced by his students. "Patterns of Beijing brick carvings all have deep cultural connotations. With different carving skills, they can easily seize children's attention. Let's take the bat design and the Chinese character 'Shou' for example [In Chinese culture, bat is a homophone for 'luckiness'. The Chinese character 'Shou' literally means longevity]. You can combine them together in different ways, there will be various auspicious patterns created, including 'five bats surrounding Shou' and 'Bats and Shou' together, which all contain wishes for good health and a happy life. As to Kylin [a kind of auspicious beast in traditional Chinese culture] and pine trees, we can create a design featuring Kylin crouching down under the pine tree, which also has a very good meaning."

Bold in innovation

As a matter of fact, Zhang Yan is not only the sixth-generation successor of Beijing brick carving, but also the founder of "China's mini ancient architecture" which is a result of his innovative efforts on the basis of the brick carving techniques passed down by his family.

The idea of creating mini-ancient buildings originated from the 1980s. His father once said to him, "Our forefathers once made wooden sculpture models for ancient architecture when participating in the building of the royal palace. They also once attempted to produce mini-brick carving models for ancient buildings, but failed for technical reasons. Now that the times have developed, it's time for you to try again." With these words in mind, Zhang started the exploration in this field. Finally, in 2003, he completed *Beijing Jixiang Gate House*, which is the first mini-ancient architecture based on brick carving in the country. Thus, his father's wish came true. Moreover, Zhang Yan opened a new way to carrying forward the mini-ancient architectural culture in the country.

During the 20-plus years of exploration, Zhang underwent numerous hardships. For the 100-odd procedures, including clay selection, kiln building and firing, he undertook them all one by one. Those tiny bricks and tiles, the size of a fingernail and as thin as cicada's wings, but necessary to the miniaturization of ancient architectures, were not available in the market and could only be produced by Zhang Yan himself. After countless failures, he finally successfully fired a piece of standard tile in 2001. He put the tiny tile on his palm and looked it over repeatedly and carefully. And then, he slept for two days and

two nights, with the small thing tightly held in his hand. Not long after that, he succeeded in firing a kiln of black tiles in miniature. When the tiles were cooled, he scooped them up from the water. Listening to the crisp sound, thus produced Zhang couldn't help shedding tears of joy.

Zhang Yan had succeeded in the miniature brick carving, but he didn't stand still. Breaking the ancestral rules that "the craft cannot be passed on to those outside the family", he adhered to productive protecting and promoting the inheritance of this traditional craft among the broad masses. He currently has more than 20 apprentices. He often tells them: "You must remember that you learn brick carving just for yourselves, but not for others, let alone for money. We'll become the ancients in 100 years' time, so, we must be responsible for our descendants. In carving, no mistakes are allowed and every detail must be dealt with properly because the people in the future will repeat what we are doing right now. If we do it wrong now, the people in the future will be misled and the craft will be altered. As an artist, we must have a sense of mission."

In an unimpressive farmhouse located in the suburbs of Beijing, Zhang Yan is concentrating on carving. An elegant peony flower on the grey brick is taking shape little by little. In the past 30 years, Zhang has been living an austere life. What has supported him all along is exactly the spiritual power and the sense of mission in continuously passing down the traditional craft.

11.

Colored Lanterns
in Beijing

Colored Lanterns in Beijing

Colored lanterns, or "lanterns" for short, typify the traditional Chinese Lantern Festival, with a history of nearly 2,000 years. In traditional Chinese culture, lanterns not only symbolize peace and prosperity, but also reflect people's dream for a better life.

Beijing lantern originated from the Han Dynasty (202 BCE -220 CE), but didn't form their own unique style until the Yuan Dynasty (1271-1368). As a matter of fact, this involves a wide range, including gauze lantern, palace lantern, lantern with revolving figures, animal-shaped lantern, metal lantern and glass-silk lantern. The skills involved in their creation comprise modeling, pasting, knitting, embroidering, carving, paper-cutting, writing and painting. The colored lantern in Beijing play an important role in the observance of local customs. In 2008, it was included in an expanded list of the first batch of national intangible cultural heritage items.

Li Banghua, 67, is a city-level representative inheritor of the ancient skill, dwelling in the Anhuili Community of Chaoyang District in eastern Beijing. His father Li Dianyuan was a clay-figurine artist

well known in the areas around Beijing and Tianjin, and his teacher, Li Dongxue, was not only a veteran artist in the making of Beijing lanterns, but also the designer for the red lanterns hanging on the Tiananmen Gate Tower in the heart of the capital. The father taught Li Banghua how to model, while the teacher led him into the world of lantern art. For Banghua, colored lanterns are way beyond a means to earn a living. Developing and inheriting the great tradition of Beijing lanterns have moved from being just a dream to a career to which he has been devoted all his life.

There are tens of big colored lanterns hanging in the Washe Museum of Chaoyang District Cultural Center, including quadrangular, hexagonal, ball-shaped, goldfish and lotus varieties. These lanterns, so exquisite, were all produced by Li Banghua.

Learning to make lanterns

In a corner of the living room of Li Banghua's home lies a stack of semi-finished lanterns, while two newly-formed hummingbird skeletons can be seen on the table. Li showed us two clay sculptures, one a statue of Avalokitesvara created by his elder sister; and the other a statue of his wife's head, of which he is really proud.

Is there any relationship between clay sculpture and the Beijing lantern? Definitely; and this should be attributed to the fact that the father, Li Dianyuan, is a famous clay-figurine artist in the Beijing-Tianjin region. Naturally, Li Banghua started playing with mud at a very young age.

Because of his outstanding clay sculpture skills, Li Banghua entered Beijing Fine Arts Red Lantern Factory. There, he got to know Li Dongxue, a master of Beijing-style colored lanterns, who became his mentor. Banghua recalls: "At that time, Mr. Hua Luogeng, a famous mathematician in the country, came up with an optimizing method known as the golden section theory. My teacher also took classes in t the theory. He brought his lantern, 2.25 meters long and 2.1 meters high, supported by four bamboo strips, to the class and asked the mathematician to calculate the golden section. Although with little formal education, my teacher could always accurately determine the golden ratio of a lantern. His lanterns chosen to hang on the Tiananmen Gate Tower are undoubtedly the king of lanterns. All in all, my teacher is really good at dealing with the shape, size and coloring of lanterns."

In those year, Beijing Fine Arts Red Lantern Factory was home to a galaxy of excellent craftsmen. The lanterns produced here were mainly sold to central government departments and embassies. They were indispensable decorations for the likes of the Tiananmen Gate Tower and State Guesthouse for major festivals. In the factory, Li Banghua devoted heart and soul to lantern making. Says Banghua, "We then had to work as an apprentice for three years to learn how to make a red gauze lantern. Each lantern involves 22 procedures. Our teacher required us to spend three months in each procedure. In this way, we could well grasp all the 22 procedures three years later."

Seeking lanterns

Colored lanterns are a cultural token of the Lantern Festival in the country, with a history of nearly 2,000 years. In ancient China, the 15th day of the first lunar month was the time for displaying the full glory of the lanterns. As time went on, colored lanterns also began to appear on other big occasions, such as wedding ceremonies, birthday parties for the elderly, and major festivals throughout the year. Celebration of the Lantern Festival in Beijing usually starts from the eighth day of the first lunar month, reaches its peak on the 13th day, and ends on the 17th day. As there are always business activities alongside the festive celebration, the Lantern Festival is also known as the "Lantern Fair".

In the Ming Dynasty, there were a number of very good handicraft workshops in Beijing, some producing various kinds of colored lanterns with wonderful workmanship. It was during the late Qing Dynasty (1616-1912) that the art of palace lanterns, previously available only for the royal family, emerged from the Forbidden City and gradually developed into a folk art with a distinct Beijing cultural flavor. In the capital, Dengshikou (entrance of the lantern fair) used to be known as Dengshi Street (Lantern Fair Street). Langfang First Alley of Qianmen East Street was also known as Denglong Street (Lantern Street), flanked on both sides by lanterns stores. Excellent lantern makers would be invited to design the advertising lantern hanging in front of stores, a common practice to attract attention and drum up business in olden days. Grandpa would take his little grandson to watch the lanterns dancing in the breeze. Each lantern is designed to tell a story drawn from Chinese history, including *Sima*

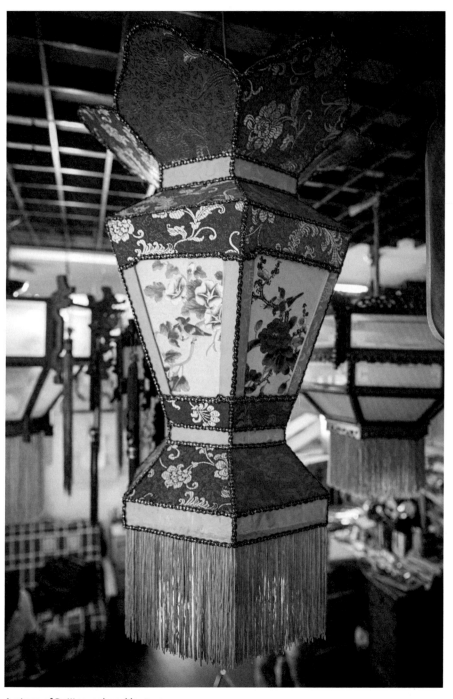

A piece of Beijing colored lantern.

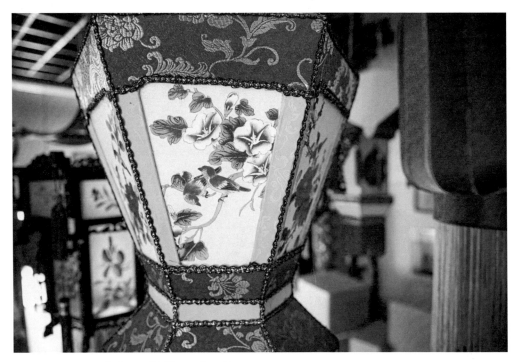

A piece of Beijing colored lantern.

Guang Breaking the Vat, Eight Immortals Crossing the Sea, The Flooding of Jinshan Temple, Kong Rong Giving up the Biggest Pear and *Cao Chong Weighing the Elephant*. These wonderful stories are well known to Chinese children and inspire them through their life.

Absorbing the best of lanternmaking from different regions across the country, the colored lanterns in Beijing have strong features of palace lanterns while developing a complete set of strict production techniques handed down through the generations.

According to Li Banghua, Beijing lanterns are undoubtedly something upscale and elegant. They are coated with various kinds of silk and satin, as well as tinsel. The lantern tassels are decorated with such

precious stones as topaz, ruby and sapphire. In olden days, the price of a high-quality colored lantern was enough for residents of a county town to cover their living costs for an entire year. "Actually, Beijing lantern used to be only for the royal family. The ordinary people couldn't afford them at all."

He continues: "To make a lantern, work should be first undertaken to paint a design, then prepare materials, especially the silk cloth; cover the wire skeleton with a layer of rice paper; painting cannot start until the rice paper has been well coated with alum; when all these tasks have been done well, it's time to prepare the gold foil decoration and knit the tassels. If the lantern is in the shape of animal, much work must be put into making it vivid. Mostly, we make fish lanterns. On top of that, our lanterns are also in the shape of fruits such as melons, pears and peaches."

In lantern making, mixing the paste seems to be less important. You may be tempted to pay little attention to this link. As a matter of fact, the paste once occupied an extremely important position in the whole process. How to mix the paste was a business secret in those years.

Producing good colored lanterns involves a number of artistic categories, such as designing, modeling, painting, knitting, welding, etc. As there was no school in olden days, the necessary skills, especially modeling, color matching and pattern selection, could only be handed down by those artisans from generation to generation. For instance, the goldfish lantern can flap its tail, and the longevity lantern (turtle-shaped) can move its feet. All these reflect the wisdom of the ancestors.

Inheriting the lantern tradition

After the death of his teacher, and despite the meager salary, Li Banghua still stuck to making colored lanterns. He independently studied graphic design, adhesion technology, and use of the acousto-optic control lamp. Cooperating with young designers, he developed a batch of works with both traditional charm and the flavor of the times. No matter whether the bespoke wine bottle lantern for Vodka, the dragon boat for a big event, the lotus lantern for the Fahua Temple or the fish-lotus lantern tailor-made for a private club, they are all so amazing. Banghua explains: "My only dream is to better carry forward the craft left by our ancestors."

In recent years, although officially retired, Li Banghua has not been idle. He has continued to promote the inheritance of the craft. "I went to the villages in Pinggu District and stayed there for half a year to popularize the art of colored lanterns without any pay. In school, I taught students how to make a lantern, how to paste, paint and stick on the tassel." He describes himself nowadays as a "lantern enthusiast".

"These years, the lantern industry faces the risk of vanishing", sighs Li. Most of the veteran artisans have gone, while few young men are willing to concentrate on the craft today. "Those young men working in the lantern workshops are mostly from the countryside seeking to earn a livelihood. With little education, they know nothing of the art, let alone the passion for studying. The lantern art is facing a serious situation where there are no longer any followers."

Despite this, Li Banghua still insists on volunteering to provide

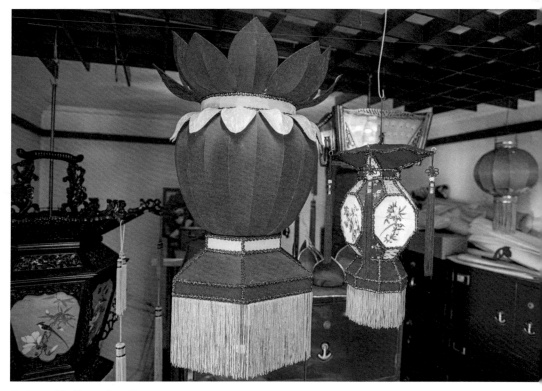

A piece of Beijing colored lantern.

technical guidance. Most often, he goes to the Lanshanchu Lantern Studio in Magezhuang Village, Jinzhan Township. Usually, he leaves home early in the morning and takes a bus to the village, where he spends most of the day in the lantern studio till late in the afternoon. He has been doing so for many years.

Liu Shaobai is a student of Li Banghua. He runs a lantern art studio, now. However, in the early days, his lantern business was not going well because of some technical problems that were not solved until he met Li Banghua.

Li not only taught students to make lanterns, but also encouraged them

to innovate boldly. In this way, Liu Shaobai made some improvements to lanterns so as to better meet the needs of ordinary consumers. "I added some flax and raw silk into the fabric. To protect eyes, I adopted the reflected light on the basis of the theory of the shadow play," he explains.

Li also tried to introduce some modern elements, such as facial makeup, oil painting and porcelain making, to the traditional handicraft. Next, he intends to make a large-scale lantern to show the picturesque scene described in the Moonlight over the Lotus Pond, an excellent prose work written by the poet Zhu Ziqing (1898-1948). "The whole scene should include the lotus leaves, flowers, buds, kingfishers, fish, frogs, the Taihu lake stone, big willow trees and a moon in the sky. Besides, it should also have background music, LED light … I'll try my best to do it. I've been devoted my life to lanterns. I really want to make it."

Although the traditional craft of making Beijing lanterns remain in the doldrums, Li Banghua believes that, as long as the traditional craft keeps up with the times, it will surely maintain its vitality and continue to be handed down through the generations.